THE GARDEN PHOTOGRAPHY WORKSHOP

THE GARDEN PHOTOGRAPHY WORKSHOP

Tips and Techniques
for Capturing Your Garden

ANDREA JONES

Timber Press
Portland, Oregon

Published in 2017 by Timber Press, Inc.
The Haseltine Building
133 S.W. Second Avenue, Suite 450
Portland, Oregon 97204-3527
timberpress.com

Printed in China
Cover and text design by Kristi Pfeffer

Library of Congress Cataloging-in-Publication Data

Names: Jones, Andrea, 1960- author.
Title: The garden photography workshop : tips and techniques for capturing your garden / Andrea Jones.
Description: Portland, Oregon : Timber Press, 2017. | Includes bibliographical references and index.
Identifiers: LCCN 2016027281 (print) | LCCN 2016032692 (ebook) | ISBN 9781604696691 (pbk.) | ISBN 9781604697865 (e-book)
Subjects: LCSH: Photography of gardens. | Photography of plants. | Gardens—Pictorial works.
Classification: LCC TR662 .J66 2017 (print) | LCC TR662 (ebook) | DDC 778.9/34—dc23
LC record available at https://lccn.loc.gov/2016027281

A catalogue record for this book is also available from the British Library.

With special thanks to my husband, Alasdair Currie, for his help and support during the making of this book, enduring with me late nights and early mornings writing and rewriting, photo editing, processing, scanning, and retouching, not to mention walking the dogs and caring for our wild garden while my mind was on this exciting project.

CONTENTS

THE GARDEN PORTRAITS

56

FINCA VIDA
Creative Composition in Southern Spain

Crafting a garden photo story
Composing your photograph

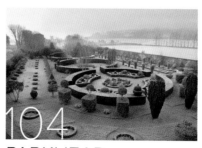

70

NARA
Up Close in a Japanese Courtyard in Dublin, Ireland

Photographing in close-up
Getting perspective correct

88

LYNN AND RALPH'S GARDEN
A Mosaic of Moments in Washington State, USA

Making a photographic patchwork quilt
Editing, archiving, and organizing your photos

104

PARKHEAD
Working with the Elements on the West Coast of Scotland

Capturing winter weather
Creating slide presentations and photo books

MILL OF FYALL
Social Media from the Vale of Strathmore, Scotland

Creating a visual diary for social media
Understanding histograms, contrast, and clarity

FARRS
John and Jennie Makepeace's Crafted and Colourful English Garden

Using colour and light to reveal a garden's character
Getting detail in shadows

NANCYLAND
Curating Creativity in Oregon, USA

Capturing the style of a garden
Playing with depth of field

ARD DARAICH
Sketching in the Scottish Highlands

Telling the story of a garden and its gardeners
Using the garden as inspiration for art

ANN STAFFORD
Compiling Botanical Records on Grand Cayman

Striving for detail and accuracy
Showing a sense of place

COYOTE HOUSE
Professionally Promoting Sustainability in California, USA

Mixing natural and artificial light
Documenting design: before and after

WHY PHOTOGRAPH YOUR GARDEN?

Gardens are ephemeral. Yet they linger long in our imaginations and they bind us with invisible tendrils, occupying our thoughts and developing ideas in our heads when we are elsewhere or engaged in other pursuits.

I have spent at least a couple of decades attempting to capture the essence of gardens, to "fix" their magical moments and uncover their secrets. I have discovered that it is through the lens that a garden truly reveals itself to me, and through my images I can often surprise the gardener who has designed, created, and tended it.

Every garden has a unique beauty. In the course of my work I have photographed a huge range, from magnificent royal palaces to small domestic yards, finding something original in all of them. No matter how grand or modest, each of these gardens is the endeavour of someone with a unique vision who has been willing to expend energy and passion in order to see that vision flourish.

For those of us who love to plan and plant, coax the wayward growth of climbers, and clear the weeds that would smother small treasures, capturing in pictures the unfolding seasons or the tiny details of buds and bark is almost irresistible. Now that digital cameras are so inexpensive, smart phones always at hand, and tablets so user-friendly, it has never been easier to catch that instant when the first snowdrop emerges or when you draw back the curtains on an autumn morning to discover that, overnight, the leaves of your maple tree have fallen in a perfect, scarlet circle.

Beyond these simple pleasures, the reasons that gardeners choose to photograph their gardens are myriad. Printed garden photographs transform beautifully into cards, calendars, or photo books—the perfect gift or keepsake for reflection and observation—and it's now easier than ever to create a visual diary on social media with one tap of a smart phone button. More practically, photographing your garden can help you remember which planting combinations worked and which ones didn't, when you planted or harvested from one year to the next, or how a garden construction project progressed.

➲ Early morning autumn light at our home and B&B, Alton Albany Farm.

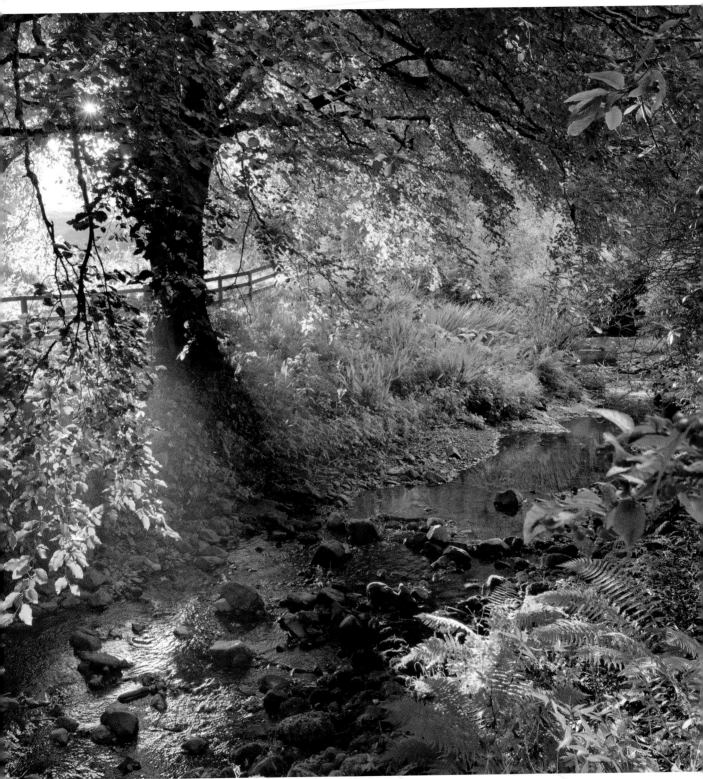

Capturing images to promote personal businesses or to entice visitors for fundraising opportunities are just a few more reasons why we may find ourselves wandering around the garden, camera in hand.

In talking to gardeners and from my own experience, I know that for various reasons these snatched photographs of our gardens can often be disappointing, failing to capture the brilliance of the moment. Yet this needn't be the case. With just a little more know-how and the willingness to practise and experiment, you can overcome many of the obstacles to taking great images.

You certainly don't need to have a showpiece garden in order to be enthralled by your outdoor space. Neither do you have to be a professional photographer to achieve the images you desire. By training your eye, adopting and practising a few new techniques, it is possible to achieve photographs that are rich in detail, reflecting your garden as you truly see it or in some cases making it look even better than it is. Above all, you should really be enjoying the process.

Mine is a garden in the making, a long-term project only recently begun. By continually photographing it I am charting its evolution, capturing the changes through the seasons and from year to year as it flourishes. While it remains immature I love to use small corners as stage sets for containers of herbs or spring bulbs or any number of other garden projects, relishing the images they give me of fresh greens or

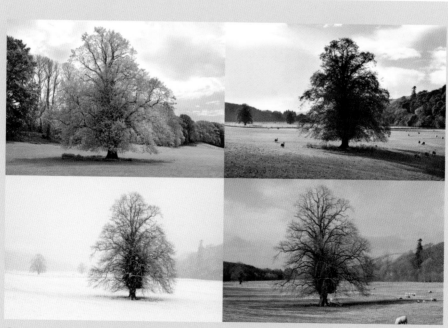

⬆ Lime trees through the seasons in Scotland's Stinchar Valley.

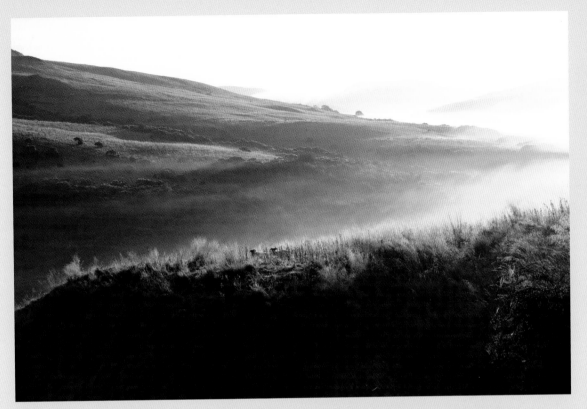

⬆ Carrick Hills with sheep.

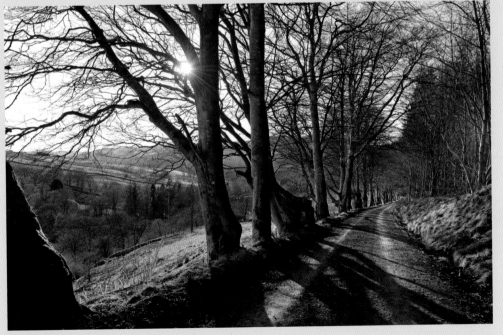

⬆ Beech avenue, Barr Trails.

⬆ Alton Albany Farm in frost.

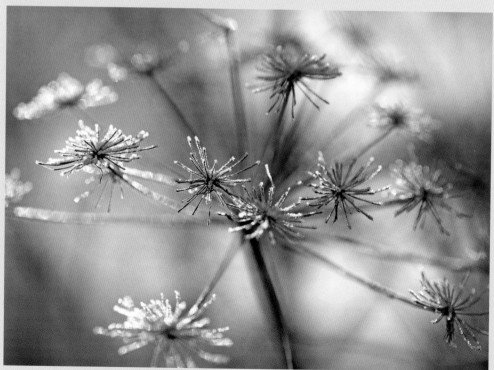

⬆ Frosted umbellifera.

vibrant colours. My husband, Alasdair, will end up using some of the photographs—the wider views of our garden and our wonderful local landscape in Scotland's Stinchar Valley—on his B&B blog to record the passing of the seasons where we live.

I have to admit to being slightly obsessed with photographing my own garden, and it's always the light that draws me out. When my garden is bathed in the golden light of early morning or in the golden hour before the sun goes down, I will often grab a camera and rush outdoors or to a window, intent on capturing the effect before it is lost. And herein lies the challenge, one that you might have encountered too, because this approach is unlike the way that I photograph for books and magazines—sometimes watching the weather closely for days or even weeks, planning each shot in advance, and even setting up before sunrise to be ready for that moment when the light is perfect. When it comes to my own garden, I am usually in the middle of doing something else when the light catches my eye. So I have to respond instinctively and react quickly to circumstances instead of anticipating them.

⬆ Our field and view to Barr Village.

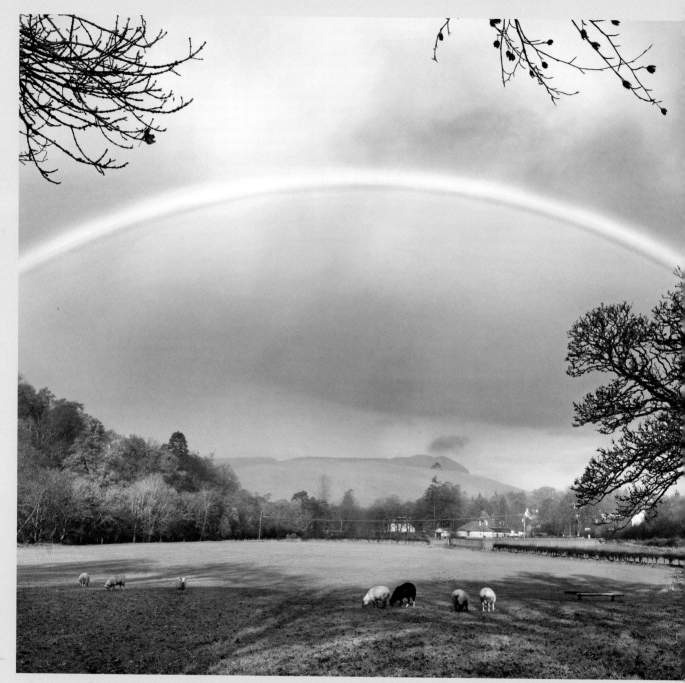

⬆ Rainbow over our field and view to Barr Village.

I understand just how tricky it can be to make split-second decisions about equipment, angles, and apertures while the sun is quickly climbing higher and higher or that coveted frost is starting to melt. Under such circumstances, familiarity with your garden and camera equipment, whatever you have, will always pay dividends. By practising some new techniques you'll be able to make your photographs more exciting yet reliable, and be ready for that magical moment when it comes.

HOW TO USE THIS BOOK

We've talked about *why* to photograph your garden, but what about *how*? That's where we go from here. In the first part of the book, we'll cover the basics of understanding your space, coming up with a photographic plan, and using weather and light to your best advantage. The next chapter delves into the vast world of camera equipment, from DSLRs to smart phones and accessories. I break down the contents of my essential photographic kit, as well as some basic camera functions and settings that may or may not be familiar to you.

When I am trying to understand a new technical concept, I always find it easier to learn when someone shows me, rather than by reading long technical explanations in textbooks. Workshops are great but are not always possible to attend for one reason or another. The second part of the book, a collection of ten garden portraits, offers a variety of photographic studies—composing a photograph, telling a garden story, capturing details in shadows, editing and archiving photos, and much more—in a unique hands-on format. With a combination of my own photos and those from the garden owners, I will present how I photographed the gardens professionally, how the owners photographed them, and what we learned from each other.

GETTING STARTED

When the American Orson Welles made the highly acclaimed film *Citizen Kane*, he was a young and inexperienced director. He knew no boundaries as to what was cinematically possible. Hence with the help of a brilliant and open-minded cameraman he fearlessly went on to explore and use filming techniques that had not previously been attempted. Learning a new skill, using new equipment, or simply starting a new project can be hard on the nerves, but the excitement should be exhilarating and the more courageous you are the more you are likely to learn and achieve.

HOW TO PHOTOGRAPH A GARDEN

→ *Knowing your garden*
→ *Decision making and planning*

I started my photographic career working with black and white film and it was through that medium that I really fell in love with photography. Once I was introduced to the wonders of exposing images onto paper using an enlarger, developing the prints on paper, and then seeing them magically appear under the dim red darkroom light, I became completely hooked.

Although I didn't know it at the time, using black and white film really helped me develop an eye for composition, tonal ranges, and negative space. Anyone who has ever admired the landscape photography of Ansel Adams, as I have, will understand what I mean.

I'm not suggesting that we all go back to using monochrome film, but if the opportunity arises, I certainly recommend the experience. Many university or college courses in photography also start their students with film cameras, some-times for the entire first year, in order to learn how a camera really works.

DISCIPLINE

Buying film and its subsequent processing cost hard-earned money. Digital equipment is hardly cheap but it doesn't incur the same ongoing expenses. Therefore many people start off thinking that by using digital they can achieve the results they want by taking lots and lots of images and then picking one or two that work. Sometimes you might be lucky: like throwing a lot of mud at the wall, some of it might stick. But I want to promote a more thought-out approach that will help you achieve the results you want when you want them.

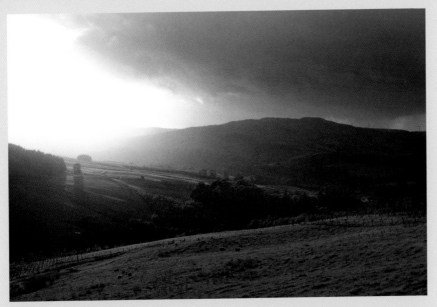

⊕ I photographed this landscape image from a nearby hill looking back to our valley and home. Not quite Yosemite National Park, but it's a tremendous location to catch the light as the sun goes down in the evening after I walk the dogs. I try to keep a camera with me as often as possible to catch these unexpected moments. When I clicked the shutter, I wondered how it might look in black and white. So when I processed the file I made a copy and converted it to grey scale.

⊕ I love the excitement of black and white imagery. It can bring an extra sense of drama to an already strong image, particularly if it has a good range of tones from deepest black to brilliant white.

There is a wealth of image-capturing equipment on the market these days and so many different ways to share photographs. Yet I think the best starting place is with some common ground—with very little equipment at all.

I run a lot of garden photography workshops, sometimes at home on our farm or sometimes at another photogenic garden location. Either way, the first thing I do when meeting my new student group is to discuss what they want to achieve. Everyone will have different ideas about what they want to document and why. Next I usually suggest a shared walk around the garden, often without a camera at all. In its place, I hand out pieces of black cardboard with a small rectangle cut out in the middle. The hole represents the camera's viewfinder—what you look through in order to compose and frame your picture. This encourages students to train their eye to look for photographs before pressing the shutter button. I often do this when I visit a new garden and I have now disciplined myself to use the idea in my own garden from time to time. It helps make me stop and think without committing to any images and I am slightly freer to think creatively when not lugging loads of equipment around. It can be quite liberating.

So why not take fifteen minutes and walk around your own garden without a camera but with a similar piece of black cardboard with the shape of your camera viewfinder cut out? Look through it as you stroll around. Remember to look for negative space as well as positive: the space around the subject can be as interesting as the subject itself, if not more so. Squint your eyes to notice tonal ranges as well as bright spots from reflections and dark black areas that you may want to avoid pointing your camera at later.

Take it one step further and use a sketchbook to record observations of anything you may want to shoot later with your camera. The process of sketching the garden can also help reveal any potentially good or bad angles. I also often suggest that my students consider themselves like fine artists painting in oils *en plein air*. If you were an artist investing time in setting up an easel outdoors and painting one scene for a whole day or more, then surely you would think carefully about your composition before laying any paint on your canvas. So think of yourself as an artist and think of your tripod as your easel. Take the time to consider your picture, and whenever possible, don't rush it.

KNOWING YOUR GARDEN

No two gardens are the same. In order to photograph your garden successfully you need to work out what is special about yours and ideally make some sort of plan. This involves having an intimate knowledge of the plants and the layout and where the light hits throughout the year. For example, where does the sun rise in the morning and where do its low rays illuminate bare stems in winter?

By photographing your garden you are not only telling the story of the plants and the wildlife that inhabit it, but also the people who nurture it and maybe those who have tended it in the past. My garden surrounds an old farm whose stone barns and walls tell their own tale of decades of agricultural endeavour.

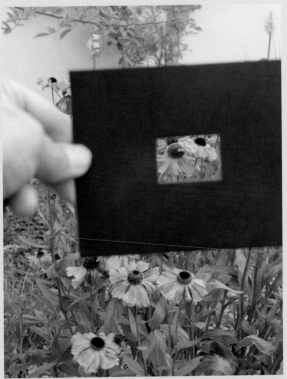

⊙ Take the time to walk around your garden with just a piece of black cardboard with a rectangle cut out. Practise composing images using the constraints of the frame. It's a good way to practise looking and it works for long or wide views as well as close-ups.

⊙ I had particular difficulty with framing our own house while trying to include it in the garden images. I simply couldn't find an angle where it didn't look stark and uninteresting. The walls looked tall and bare, and I was on the point of giving up, writing it off as an ugly house. However, I tried the cardboard viewfinder technique and found this view by positioning myself in a corner of the next field under a stand of beech trees, which framed the house and softened its rather austere look.

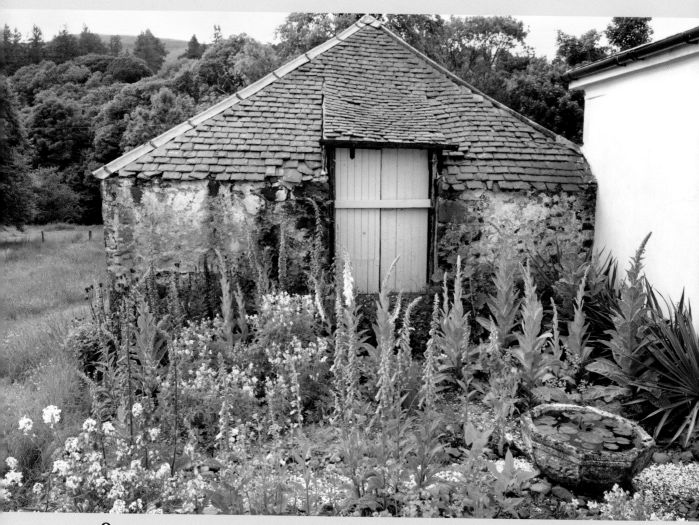

↑ View of the office garden against the backdrop of our old mill.

Photographing your garden may cause you to look closely at things that perhaps you could have overlooked, and your space may change for the better in the process. You might just start to see it differently, to reassess plant combinations, to consider adding features that could enhance your photographs and your garden. The more you view your garden through a lens, the more you may be inspired to edit both. Knowing what to leave out can be as important as deciding what to include.

Our garden at Alton Albany Farm is barely recognizable from the one we took on from the previous owners. We have planted borders, made new garden areas and paths, sown a meadow, and added many trees. All sorts of plants, some more welcome than others, have seeded themselves into our gravel beds.

Its own wild nature is a continual source of inspiration and a theme to which I constantly return. The way in which the garden changes fascinates me and I have recorded the process of transformation by photographing the same views through all seasons. Looking back now over some of these pictures I find myself astonished by how the garden has evolved in just a few years. The photographs serve a practical purpose, helping me to assess what works and what still needs to be done. They are a reminder of successful designs, such as which plant associations have had greatest impact, and prompt fresh ideas for colour themes and seasonal displays. They also provide an *aide-mémoire* to those failed attempts.

⬆ Mown paths in the orchard around old apple trees.

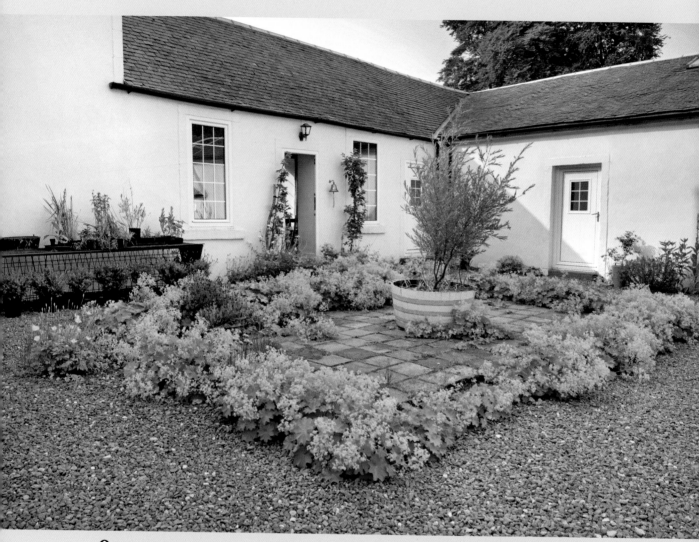

⬆ The courtyard in full colour.

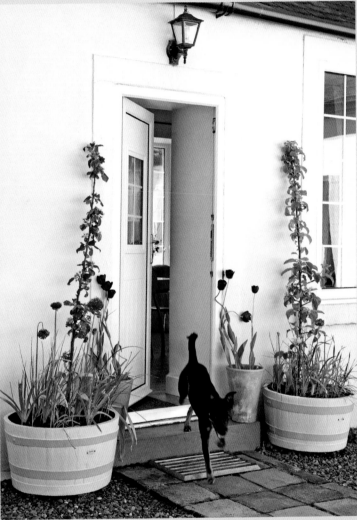

↑ A corner of our courtyard with a container of nasturtiums.

⊘ Details of the courtyard with Daisy-Mole the dog.

From the photographs I can see how startling our decision to paint the boundary wall a tone of aubergine must have appeared to the local villagers. Later photographs show that the wall has mellowed, softened on one side by the tall native grasses and wild flowers on the verge and on the other side by dog roses (*Rosa canina*), planted as whips and now flourishing.

Photographs can help you to look at your garden with a fresh eye, to capture what might not be evident at first glance or that familiarity has rendered invisible. It is so easy to fall into a rut, always standing with your camera in the same spot. Your most familiar view might be the one that you see from the kitchen window, so take a walk to the furthest point away and look back at the house—you may be surprised by what catches your eye as new angles reveal hidden features.

Looking down on your garden from an upstairs window—the bird's-eye view—is always interesting with the patterns that it reveals, but don't let it monopolize your photographic records. The worm's-eye view can be just as fascinating. Experiment by lying flat on the grass, peering through stalks and stems, before turning onto your back and gazing upwards into the branches.

Finally, just as a jockey will walk the course before riding in a race, get into the habit of walking around your garden in all kinds of weather to really get to know it. Having several dogs can be helpful!

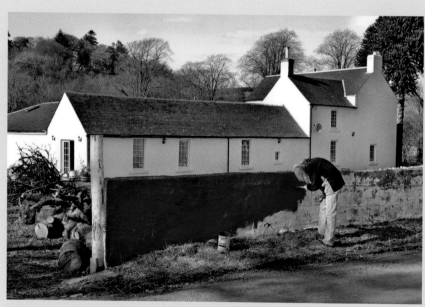

↥ Our friend Jayne helping to paint the wall aubergine.

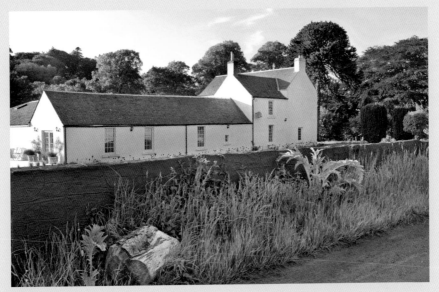

⬆ The painted wall, once the grasses and flowers filled in a bit, and our slate roof with its purple sheen that inspired our colour choice for the wall.

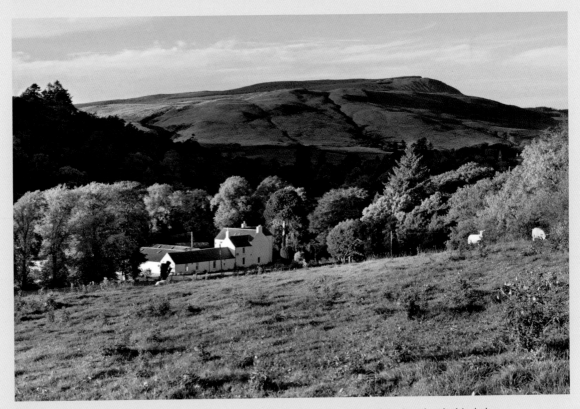

⬆ This wider view from the hill opposite our home reveals that the tones of the heather behind also blend in with the new wall colour. The soft morning light is kind to the landscape and shows the detail of the foliage and undulations.

⬆ Detail of old barn wall with roses and the grass *Phalaris arundinacea*.

⬇ View of the front entrance to our home fringed by a collection of our planted containers.

⬆ Lying flat on the grass in our meadow of clover.

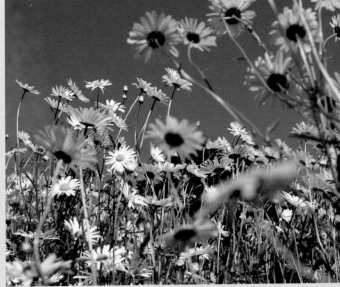

⬆ Clover (the dachshund) in our meadow peering over the grass.

↘ Taking the worm's-eye view of ox-eye daisies.

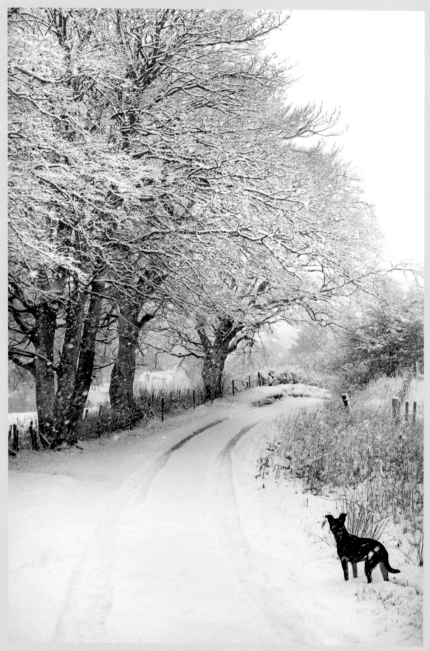

⊕ Exploring in frost and snow with Daisy-Mole.

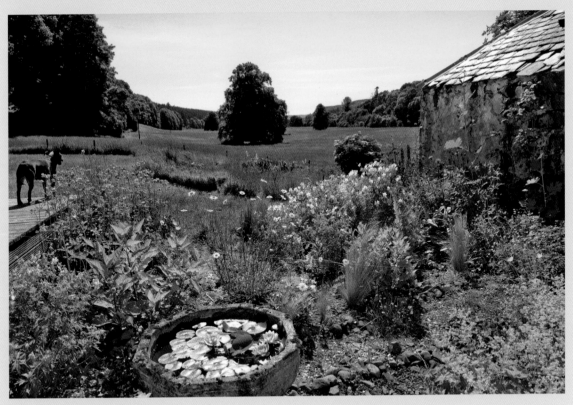

⊕ Daisy-Mole on the deck by the office garden.

DECISION MAKING

Photography is all about making decisions, and capturing gardens is no exception. Although you can get results in a random and haphazard way, to achieve consistent results—to be able to repeat your success—you need to rehearse your shots. This involves deciding what you are going to photograph and knowing what position to take when the weather and light are favourable.

Before photographing a garden professionally I dissect it in a formulaic way, determining its angles and attitudes, scrutinizing its strengths and weaknesses, and formulating a plan of how I will capture the best of the garden. If possible I do this in advance, sometimes taking a day out to do so, only returning for the photo shoot when I am as sure as possible that the conditions are going to be right. Making such an objective assessment of one's own garden can be more challenging, but the steps that I work through for every project make for a useful guide.

I recommend using a compass—a smart phone compass app, a compass built into your camera, or a real compass—to get an idea of light direction and potential shadow. I also find that drawing a rough plan or map of the garden helps. At least make a mental note of where north is or draw a little compass on the plan. All this

helps the process of anticipation. The more you get to know your garden and the direction of the light that will fall on its features and shimmer through the foliage, then the better will be the results you will start to see.

Next, break the garden down into smaller projects. First, it is important to look at the garden in its surroundings and acknowledge its own sense of place. This element doesn't always have to include a picture of the garden at all—just the environment in which it sits. For me the Stinchar Valley with its surrounding hills, rolling mists and rain, sunshine and rainbows, and the atmosphere those elements bring, are what I endeavour to capture. If I were photographing a coastal garden then I'd want a sense of the sea and the tone with which it meets the land—harsh rocky cliffs or gentle sand rolling into dunes. In the city I'd want to show the architecture, whether contemporary or historic, that surrounds the space.

After establishing the garden's surroundings, look for the widest view, the one that covers as much of your garden as possible. I have an old panoramic film camera that I still use to great effect to capture these views on occasion. The panoramic feature on a smart phone would also work. Getting up high for a garden overview (from an upstairs window or even a ladder) is another great option. I try and pull together as much as I possibly can of the garden into one shot. If that won't be possible with your equipment, consider building a montage of images (see page 92) or patch together like a quilt (see page 93) to give a flavour of the whole space.

Then it's a question of drilling down methodically through the levels of garden areas or rooms, beds and borders, planting combinations, garden features and artworks, specimen trees, shrubs, and architectural plants. After that come the individual flowers and—what many find to be the most exciting part—the close-ups. There is no end to how these areas and subjects will look in different seasons and it's completely fascinating to see how the weather and light change the appearance of each element.

More practically, you may also want to document the processes you used to achieve particular effects in your garden, for example, the rose-pruning techniques that gave rise to epic flowering the following year. For these you will probably want to include members of your family or friends or even take selfies to record practical tips to remember.

SEQUENCE OF PHOTOGRAPHS

This is the plan that I follow when I photograph a garden and it helps me be sure that nothing is overlooked. I would like to say that I always follow the guide in my own garden too, but life is not like that. So, I do what I can when the weather is right or when I find a window of time in a busy working day.

Even just an awareness of the sequence, with its progression from wide images of landscape and setting down to the tiniest details, may help you to find new ways to photograph your own garden and perhaps make you consider aspects that you hadn't previously thought of including in your images.

The plan starts at the top with the photographs that set the garden in its place and then follows a logical path through the architecture, landscaping, plants, people, and pets that populate the garden. The left-hand column covers hard elements and practical projects; the right-hand column groups together ideas for photographing the many different natural forms found in the garden. Between the columns lie the factors that can influence all or any of these subheadings: weather, seasons, magical moments, disasters, highlights—all of which are beyond our control—provide an eternal source of changing images to record and enjoy.

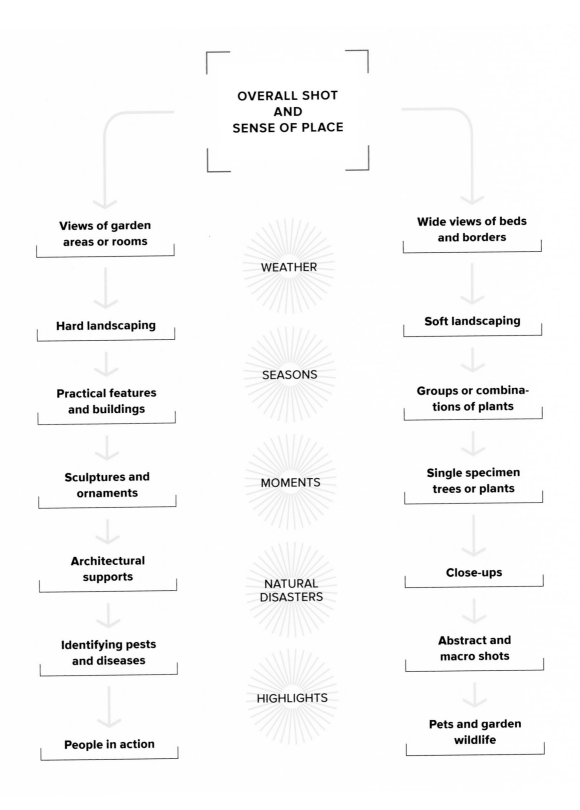

OVERALL SHOT
AND
SENSE OF PLACE

Views of garden
areas or rooms

Hard landscaping

Practical features
and buildings

Sculptures and
ornaments

Architectural
supports

Identifying pests
and diseases

People in action

WEATHER

SEASONS

MOMENTS

NATURAL
DISASTERS

HIGHLIGHTS

Wide views of beds
and borders

Soft landscaping

Groups or combina-
tions of plants

Single specimen
trees or plants

Close-ups

Abstract and
macro shots

Pets and garden
wildlife

PHOTOGRAPHING PETS AND WILDLIFE

Although pets are always great fun to photograph and wildlife extremely challenging, the rewards are huge. It's hard to exclude animals or birds in some shape or form from your garden, so why not include them in your garden photo story? Pets soon become part of our families and their antics never cease to amuse us. So it can be fun to record them, and the results will create a smile or two. Why not also try looking from their viewpoint at the scene around?

It always feels such a privilege to have wildlife visit our garden, but they are more time consuming to photograph. It can be quite a waiting game. I like to leave out seeds for the birds to encourage them into our orchard where blackbirds enjoy fallen apples and our red squirrels also respond well to a few hazelnuts scattered under a tree. I know there are plenty of moles and voles around too, but they so far have proven more elusive.

We were lucky enough to get to know a tiny leveret (a young hare) last year. I documented the story of his rescue and recovery with the help of an expert at a wildlife sanctuary and included the picture story in Alasdair's blog.

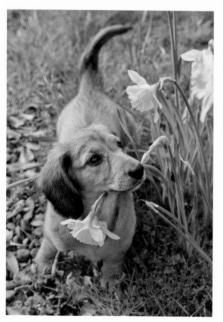 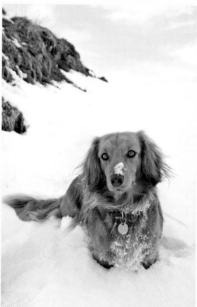

⬆ Clover and daffodils.

⬇ The antics of our dachshunds never fail to raise a smile and lift the spirits. Clover has become a practised model.

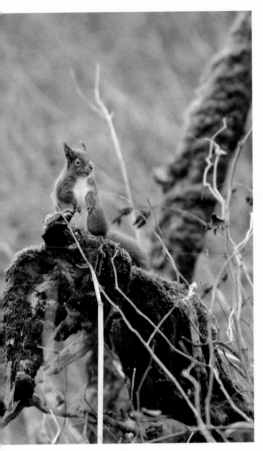

⬆ Red squirrel.

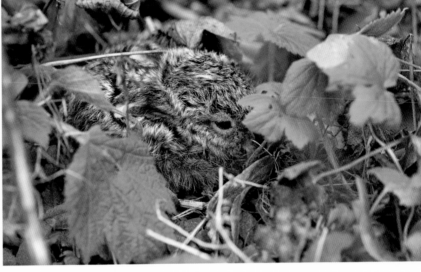

⬆ Leveret in the wild.

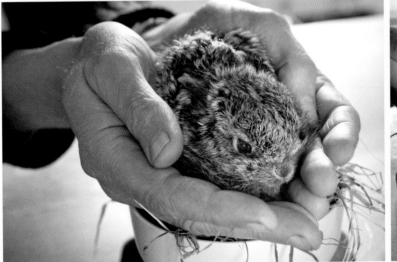

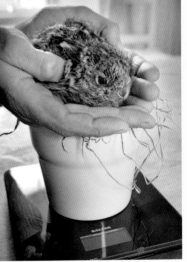

⬆ ⬇ Leveret being weighed.

WORKING WITH WEATHER

Before travelling to photograph a garden, or when planning time off to take photographs in my own garden, I usually consult three online weather forecasts and average out their results. In the United Kingdom I use the Met Office or the BBC (which are very similar), AccuWeather, and yr.no (a Norwegian weather website that seems accurate for anywhere in the world including the USA). For forecasting in the USA I use AccuWeather, The Weather Channel, yr.no, and the U.S. National Weather Service.

Forecasts seem to be becoming a little more reliable over the years, but they are still far from foolproof—for accuracy three days in advance is about as good as you get. However, when I have long-distance travel plans and tickets to book, then I fish around the Internet as much as possible for local forecasts for my commissions and projects. It's only when two out of these three sites agree that I seriously start making travel plans.

Our own climate is most similar to that in the U.S. Pacific Northwest, often stormy, cold in winter, and wet any time of year. But what is the best kind of weather anyway? It's endlessly debatable and depends largely on the effect you want to achieve. If I were photographing a distinct and beautiful landscape, I might say the sort of extreme weather you find in the English Lake District—dark skies and breaks in the clouds allowing streams of light to fall. Dramatic weather can make a much more interesting picture than a perfect clear blue sky with little fluffy clouds, although that may not show your garden off to greatest effect.

The right sort of weather is even more essential if you have just one chance to achieve the images you have set your heart on, such as a long-anticipated visit to The Alhambra in Granada, Spain, for which tickets have to be booked months in advance, or the Chelsea Flower Show in London, the pinnacle of British garden shows. I go there on Press Day and have just a narrow window in which to capture it, so I dream of a clear, still morning from sunrise offering gentle dappled light on the show gardens, a light haze to diffuse the sun's rays and prevent contrast and strong shadows as the day progresses, then clear skies and low golden light from about 5 p.m.

As you'll be photographing your garden throughout the seasons, depending on your climate, you'll be able to watch out for opportunities to capture your garden as the weather affects it: bright green shoots as spring appears followed by pastel-coloured blossoms, colourful summer perennials followed by autumn tints. It's impossible to order the weather you want so you have to make the best of what you get. Don't always wait for a blue sky—some of my best pictures have been taken in a thick mist or in a light summer haze. Blue sky can look impressive at any time of year but brings sharp contrasts, and although it can create striking images, the bright light it brings with it can be harsh on plant details and can throw garden scenes into deep shadow.

LIGHT

Elusive, ever-changing, sparkling on frost, or filtered through fog, light is the magical ingredient that makes photography possible. To get it at its best you generally need to get up early. Light changes colour as the sun rises higher in the sky. As the day progresses it can suddenly become too bright and contrasty for photography, but even on a bright day in the early mornings the light can be perfect, illuminating small details and casting a golden glow through the foliage of trees upon the garden. This is the time when you may find yourself transfixed by a spider's web studded with dew or astonished by intricate veining on leaves that later in the day are much less visible.

Photographers will often talk reverently about the golden hour. More accurately, we should discuss golden hours, as they occur during two parts of the day—roughly the first hour of light after the sun rises and the last hour of light before the sun sets. You can use online sunset and sunrise apps to estimate times for your local area. These

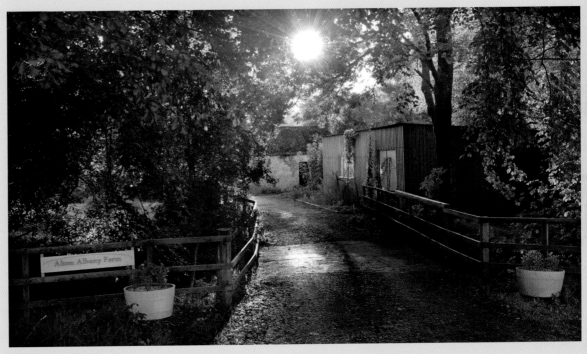

⬆ Entrance to Alton Albany Farm.

are times in which the sun sits lower in the sky and produces a more flattering, soft, diffused light as compared to the harsh sunny light that you might want to avoid photographing into during the middle of the day. The light of the golden hours may suffuse the scene with a warm glow. If you are taking photographs in a public space rather than your own garden, you may notice an additional benefit of these times of day: fewer people to disrupt your perfect shot. There is also a certain stillness that often occurs in those first hours of the day before the light breaks through.

Of course, what light you have to play with—golden hour or not—depends on where you are in the world and the time of year. Near the equator it can be bright at 6 p.m. and dark just moments later, like the switching on and off of a light. In summer in the north of Scotland, light arrives early and remains perfect for photography until much later than it does elsewhere. On the West Coast of the United States the light is mostly harsh and bright, but travel north into Oregon and it becomes more European in character and by the time you reach Seattle the grey, overcast skies allow for photography throughout much of the day.

For the Chelsea Flower Show, the photographers arrive at 5 a.m. At that hour in London in mid-May, assuming we get reasonable weather, the light is still slightly dim, but by 6 a.m. it should be perfect and could remain that way until 7:30 a.m. Except for Press Day when we are allowed more time, that hour and a half is all we have to get our work done and portray the gardens and plants looking their best. What do you do on a garden tour if you don't reach the garden until 10 a.m.? That's not ideal, of course. With digital photography there are ways around it which we will explore later in this book; if you are using film between 10 a.m. and 4 p.m., hope for a bank of cloud cover that will diffuse the sunshine.

What is important is that you capture your garden when it is looking its best. There is no point waiting for the perfect light on a sunshiny day if by that time your border has passed its peak. If you oversleep and miss the early light then go out and photograph anyway—better to get some record than regret missing that horticultural moment of splendour. Equally if you only have one chance to visit an inspiring garden and won't be able to return, then use your camera to your best ability in the time you have. Just try and avoid deep contrast of shadow and highlight in one frame.

THE EVER-CHANGING WORLD OF CAMERAS AND DIGITAL DEVICES

→ *DSLRs and lenses*
→ *Compact cameras and point-and-shoots*
→ *Smart phones and tablets*
→ *Camera basics*

An amazing, albeit somewhat bewildering, amount of photography equipment is on the market—many varieties and qualities of DSLRs, mirrorless cameras, micro four thirds system cameras, compact cameras that shoot RAW files and those that don't, point-and-shoot cameras, smart phones, and tablets. By the time this book is published you will be able to purchase gadgets and apps that do things that I never dreamed possible. So, while I can't really offer advice as to exactly which piece of equipment to buy, this chapter will help break down the basics of camera equipment, digital devices, and settings. There is something available for every convenience and pocket. Mostly, it depends on how much control you want over your images, how much you are prepared to spend, and how much equipment you want to carry around.

DSLRS AND LENSES

In order to get the highest possible quality of pictures, which you may also want to print from, you will need a digital single-lens reflex (DSLR) camera. A reliable DSLR along with a good post-processing computer application (such as Adobe Photoshop or Lightroom) should enable you to capture images and process them in RAW file format. The RAW file captures the maximum amount of information that the camera's sensor is capable of recording and no information is compressed, which means that you'll be able to make more dramatic adjustments, without damaging the image file, with your post-processing applications than if your photo had been taken in a compressed file format such as JPEG. Personally, if I were about to buy a new DSLR, I would make sure that it had two things: the capacity to capture RAW files and a depth of field preview facility.

Most lenses will have a mm (millimeter) number printed on them that refers to the focal length: the higher the mm, the longer the focal length of the lens. Zoom lenses have a range of focal lengths, such as from 24mm to 70mm, whereas prime lenses have a single or fixed focal length.

A zoom lens, as one would expect, zooms in or out to get closer to a subject or further away. With regard to optical quality, prime lenses are usually considered superior. However, modern technology has increased the quality of zoom lenses enormously and you can find some superb ones on the market. The obvious advantage of the zoom is that you don't have to change lenses so often, making them quicker and easier to use. This also protects the camera's sensor as frequent lens changing can let in dust and dirt, which marks the sensor and leaves greasy spots on your image. I always check my images carefully on my monitor screen at 100 percent magnification to make sure there are no such marks. Some cameras self-clean; others need to be professionally cleaned from time to time.

In DSLR terms generally, a 24mm focal length lens is regarded as wide angle so is a good lens to have for garden overviews. A 50mm lens is usually referred to as a standard lens, a good all rounder that's useful for most subjects. A 70mm lens is known as a portrait lens, just the right length for photographing people or plants from a comfortable distance, not so close that you make a person feel uncomfortable and for flowers you can photograph from the edge of the border without treading on

the other plants around. A 105mm lens is a little longer still and my micro version gives 1:1 (one to one) magnification. Anything longer than 105mm I'd class as a telephoto lens.

The higher the mm the longer the focal length of the lens. With a 300mm, for example, you will be able to get a reasonable photograph of a bird on a feeder in the garden. Longer than 300mm, say a 500mm lens, might be useful to photograph a bird in the sky. Longer lenses are used by wildlife and sports photographers and paparazzi; they are not essential for garden photography.

MACRO, MICRO, AND CLOSE-UP?

The word *macro* means big and the word *micro* means small, but in photography macro and micro indicate the same thing. The name of the Nikon macro lens that I use, for example, is the 105mm Micro Nikkor, while a similar lens from Canon has the word "macro" in its product name. If the subject you are photographing is small and you want to make it look big, then you will end up with a "macro" or enlarged image of a "micro" or tiny subject.

Photography is generally regarded as macro when it achieves a magnification ratio of at least 1:1. Strangely some brands don't always stick to this rule so do careful research if you are buying yourself a new lens.

Close-up photography is simply the act of photographing objects such as flowers or insects at a close range so the subject fills the frame. As an example, if I were photographing a garden spider in a web I'd regard this as a close-up photograph, but if I were photographing the tiny stamens of an alpine flower 1:1, I'd use a macro or micro lens so it could be considered macro or micro photography.

COMPACT AND POINT-AND-SHOOT CAMERAS

Sometimes I would be delighted to ditch my heavy DSLRs and work in a more relaxed way using a good-quality, lightweight compact camera. I have tried a few brands and various models over the years, excitedly hoping that my life would be changed, but I have yet to find one that I would have enough confidence in to take with me on a professional photo shoot.

However, if I were only taking images of my own garden for pleasure and record, I might be tempted to take this route. As you might expect, compact cameras vary hugely in quality and price and you get what you pay for. Some compact cameras offer many manual and automatic controls, will capture images in RAW, and have top-quality interchangeable lenses and high-capacity sensors. It is now even possible to buy a compact camera with a powerful 10×–26× optical zoom lens, which can take you from a decent wide angle to serious telephoto coverage. However, beware that some compact cameras may boast an impressive built-in zoom lens when in fact they have a digital zoom.

If you are looking for an element of control, but don't want the weight, size, or cost of a DSLR, then a compact or point-and-shoot camera is probably the answer. Some even fit in your pocket.

SMART PHONES AND TABLETS

Smart phones and tablets can give you surprisingly good results too, and because they are small, easy to carry, and fun to use—and often our main communication link—most people tend to have one on hand for that spontaneous moment.

At this point, smart phones and tablets generally have a built-in camera lens with a set focal length that allows for little flexibility towards shooting a variety of subjects.

To add to this, when the user operates the digital zoom facility, it is not a true zoom as with an optical lens. Digital zoom in effect crops a portion of the image and then enlarges it. The quality will certainly be good enough for posting photos to websites or social media, but it won't be great for printing.

With the explosion in ownership of these devices, accessory companies have developed tiny external lenses that try to replicate the flexibility of their larger siblings in the dedicated camera field. Specialized companies offer a range of telephoto, macro, zoom, and fish-eye lens accessories for smart phones and tablets. Tiny tripods are available, along with myriad other options including remote Bluetooth buttons to fire your device's camera without causing unnecessary movement. The quality and size of images taken on smart phones and tablets will only continue improving as companies attempt to make everything easier for us to use.

Image processing can also take place within your device using an app. It's incredibly easy to crop your images, apply filter effects, accentuate colours, and adjust contrast before uploading them directly to social media. I use a smart phone myself quite often when I want to upload a fun moment, an idea, or simply a beautiful view to show my friends and colleagues. I like to use Twitter, so I tweet images from time to time.

The selfie stick is a popular accessory that allows you to hold the phone away from yourself and point it towards yourself and your friends. I don't own one, but I often carry a small piece of tack (such as Plasticine) to position my phone temporarily on a secure surface to avoid camera shake—or indeed if I want to use the video setting.

One function I love on my phone is the panoramic feature. It's a lot of fun and when the situation is right I can record a wide open space or a long border in one smooth action. The image will be distorted and the perspective inaccurate but it gives a quick fix to tackle an angle of view that outflanks most single exposure formats.

CAMERA BASICS

APERTURE, F-NUMBER, AND SHUTTER SPEED The opening within the lens through which light enters the camera is the aperture. An f-number or f-stop is the ratio of the focal length of a camera lens to the diameter of the aperture being used for a particular exposure. For example, f/8 indicates that the focal length is eight times the diameter.

The maximum diameter of the lens opening is referred to as its maximum aperture or minimum f-number. The minimum f-number is the smallest f-number that can be selected with that lens. The minimum and maximum aperture varies from lens to lens, and the maximum aperture is often included in the lens model name.

The lower the f-number, the larger the aperture. The larger the aperture, the more light will be let through and you accordingly will need a faster shutter speed to maintain the same exposure. The higher the f-number, the smaller the aperture. Allowing less light into the camera means you will need a slower shutter speed for the same exposure value.

Shutter speed is measured in fractions of a second. The faster the shutter speed, the quicker any action is frozen, which is especially useful for photographing wildlife in the garden. Conversely a slower shutter speed allows action to blur, an interesting effect for capturing movement in long grasses, for example. To understand the effects of shutter speed on your subject, you might want to practise by photographing running water.

DEPTH OF FIELD (DOF) Often the hardest element of photography for me to explain to my students is depth of field, as it seems to strike fear into the hearts of the boldest pupils. DOF is the range over which any subject in front of the lens will appear acceptably sharp. It lies both in front of and behind the plane of sharpest focus and is affected by the aperture of the lens, focal length, and image magnification.

By varying the aperture you will achieve different depths of field and determine how much of your subject range is in focus. If you wish to capture a shallow depth of field with little range from front to back in focus, you will need to use a larger aperture, with an f-stop such as f/2.8. If you want to have a larger or deeper depth of field to keep more of your range from front to back in focus, then you need a smaller aperture. with an f-stop such as f/8 upwards.

When you view your scene through the camera viewfinder, it shows you the image as if the aperture was wide open, fooling you into thinking you are using a shallow depth of field and blurring some objects out of view. Some cameras have a depth of field preview button—I use this feature constantly and would definitely not want to be without it. If you depress the preview button when using a small aperture, it will reveal how the camera will actually capture the image—although be prepared for the picture to look darker as a consequence.

ISO This stands for the International Organization of Standardization. Formerly known as ASA, it is the measurement of film speed—a photographic film's sensitivity to light. The speed was determined by the amount of grains of silver halide that were distributed in the light-sensitive emulsion that would be exposed momentarily to the light and create the image. The use of the term has continued to this day even when we refer to digital image capture. In film terms the lower the film speed the slower the film: 50 ISO being low and slow, 1600 ISO being relatively fast. Digital cameras have sensitivity adjustments that are equivalent.

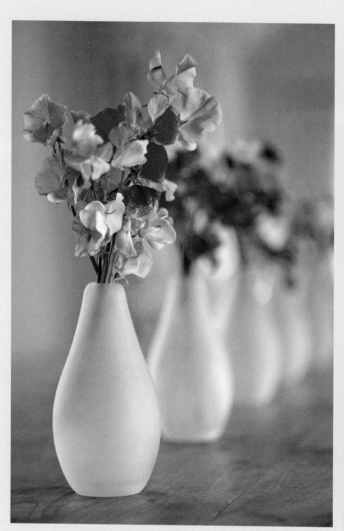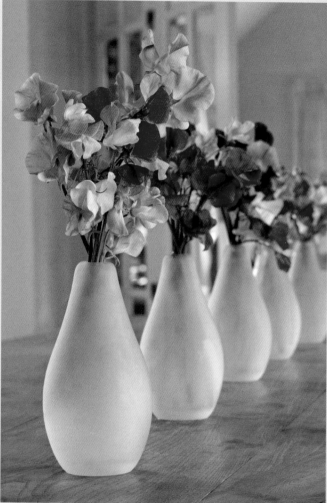

⬆ ⬇ This simple set-up on our kitchen table shows five small vases of freshly picked sweet peas. I lined up the vases and put my DSLR on a tripod with a 105mm lens. I focused on one point only on the flowers in the nearest vase. Using a cable release and not moving the camera at all, I took one frame at f/3 to illustrate shallow depth of field (above left) and another at f/16 to illustrate a greater depth of field (above right). Look how clearly you see the vases in the background in the image shot at f/16. You can try this simple exercise at home to get a better understanding.

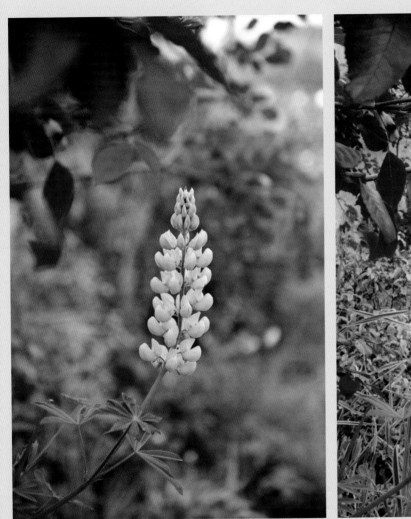
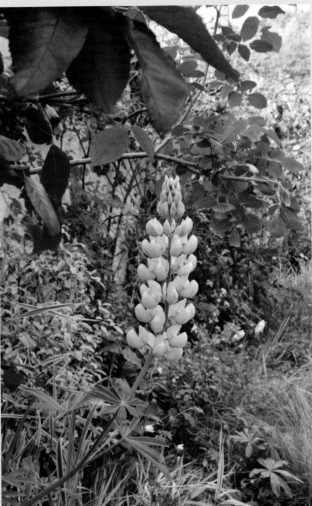

↑ ↗ These two images show simply how you can use depth of field—or lack of it—to isolate a plant from its background. In our garden I set up my DSLR with the 24–70mm zoom and attached a cable release. I focused on the lupin and took two images, one at f/2.8 giving a shallow depth of field and the next at f/22 giving a much greater depth of field. You'll notice how much more detail there is in the background of the second image while the first image makes a feature of the lupin flower head.

LIGHT METERING Most cameras these days have clever built-in exposure meters. Even modern 35mm single-lens reflex (SLR) film cameras have through-the-lens (TTL) meters that measure the amount of light available to help you determine the best exposure. These types of light meters are called reflective meters as they measure the light bouncing off your subject and into the camera lens.

If you are serious about improving your photography and haven't already tried using a film camera, this is a really good way to learn the rules and disciplines. If you want to try using a film camera without a light meter, I suggest acquiring a handheld meter to use. Handheld meters can be reflective or take incident light readings. Incident readings put the light meter directly in the light of the subject to capture one light source instead of an overall average.

↪ With most DSLRs, compact cameras, smart phones, and tablets, correct exposure is usually determined by the area at which you point your lens (reflected light). If you were looking at this subject, then your reading would change according to where you pointed your camera.

THE SUNNY 16:
FILM EXPOSURE WITHOUT LIGHT METERS

When shooting landscape images and a light meter is not available, you can follow a set of rules that is generally known as the Sunny 16 instead of wasting film trying to guess your exposure. On a sunny day with no clouds overhead, set your aperture to f/16. Then set your shutter speed to the ISO film speed of the film you're using. This should leave you with a nice, even exposure.

With this in mind, be aware that your shutter speed may not always match the ISO film speed perfectly. For example, there isn't a shutter speed 100 for 100 ISO film. The Sunny 16 rule then tells us to use the next highest shutter speed above the ISO film speed. So for ISO 100 you would use shutter speed $\frac{1}{125}$ of a second. It's much easier to remember that shutter speed equals ISO film speed, but the shutter speed will likely not match exactly.

On a bright sunny day, f/16 will expose correctly. On days that aren't clear and sunny, you can still use the Sunny 16 rule with some adapting. On extremely bright days with contrasty shadows, use f/22; on days with hazy sun and soft filtered shadows use f/11; on cloudy days with barely any shadows use f/8; and on completely overcast days with no shadows at all use f/5.6. The same shutter speed rule applies regardless of the aperture used. In our example of using ISO film speed 100, the shutter speed will always be $\frac{1}{125}$ of a second. This is all very well for landscape images but remember when mid-range and close-up photographs are concerned it's back to educated guesswork.

While generally successful, light meters are often quite flawed in areas of great contrast. Because contrasting images may contain white areas, mid-grey areas, and black areas, the light meter is forced to take an average reading.

HDR (HIGH DYNAMIC RANGE) AND TONE MAPPING Our eyes can see a much greater tonal range than any camera can, so when you photograph from a dark place towards the light you may lose details in the darker foreground and also in the bright highlights. In situations like this I take a number of different exposures known as the High Dynamic Range (HDR) and blend them together creatively—a process called tone mapping.

The best method to use and the level you can achieve depend on what equipment you have available, but in principle to tone map images you need to take a series of shots at different exposures that cover the dynamic range of the scene without moving the camera between each frame. This can be done by bracketing (taking a number of different exposures) or by using an automatic HDR setting if you have one on your camera. I would then blend, or tone map, the images either manually using layers in a

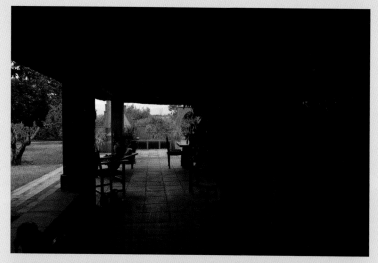

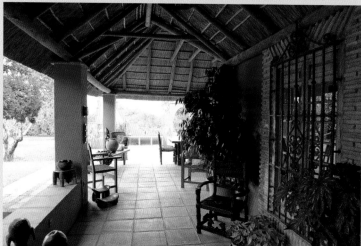

◔ To create tone-mapped images you need to start by capturing a series of images at different exposures without moving the camera. This image file is exposed for the lighter area in the distance, leaving the verandah in dark shadow.

◔ Here I exposed for the shaded area in the foreground beneath the thatched roof. Beyond that the image is now overexposed and appears burnt out.

◔ By using a software application (or I could have worked manually) to blend together the two image files taken at either end of the dynamic range of the scene, I was able to creatively merge—or tone-map—both the foreground and the distance. Both light and shaded areas now exhibit information which can be seen in detail.

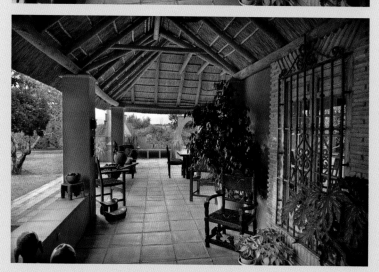

post-camera processing application or automatically (with an HDR app) using a software programme after downloading the image files. These examples are from Finca Vida in Spain, which we shall visit shortly.

Some smart phones and point-and-shoot digital cameras do a version of tone mapping by taking overexposed and underexposed shots sequentially with the high dynamic range (HDR) function and combining them into one image often using algorithms. Look for the HDR setting. My DSLR also has an HDR setting which can be used when the image capture mode is set to JPEG or TIFF. It cannot operate in RAW because this setting already offers some elasticity in exposure range.

WHITE BALANCE In digital photography white balance means adjusting colours to remove colour casts so that the image looks natural, like it did when you first took it. Colour casts mostly come from different light sources, often artificial. When you photograph a scene indoors, tungsten lighting, for example, can cause an orange cast on your pictures, whereas fluorescent light will create a blue or purple tinge. Our eyes automatically adjust, but our cameras see it as it really is and record it that way.

BASIC GUIDE TO FILE FORMATS AND SIZES

The file format and size in which you shoot your photographs is important. Along with RAW, the other possible file formats for capturing photographic data include JPEGs (Joint Photographic Experts Group) and TIFFs (Tagged Image File Format). TIFF files can be significantly larger than JPEGs and can be either uncompressed or compressed using lossless compression. This means that when you resave a TIFF you cannot damage it. A JPEG, however, reduces file size and will deteriorate slightly (lose information) every time you save it.

What are you using the end results for? If your photos are only ever going to be for web or screen use, then a digital compact camera that just shoots JPEGs might do, but what if you come up with an absolute cracker of an image and then decide you want to use that picture to make a poster for the wall? You might find that the file size produced by your compact camera is just not large enough.

In order to print digital images you need to have enough pixels to cover the page. *Pixel* is an abbreviation of "picture element." It's the smallest unit of digital imaging used or produced by a digital apparatus. A megapixel is a million pixels.

To print images on paper or indeed publish work in books or magazines, you usually need to prepare images at 300 dots per inch (dpi), whereas if you were intending to display your images on your computer monitor or publish on a website or social media then you'll need a smaller number of ppi (pixels per inch) depending on the resolution of the screen, making a much smaller file size per image.

When purchasing a camera you need to consider the image-capturing sensor sizes to cover these eventualities. For example, a sensor size of 6.3 megapixels will give you enough pixels to cover a print of 7 × 10 inches at 300 dpi; a sensor size of 17.5 megapixels will give you enough pixels to cover a print of 11 × 17 inches at 300 dpi. My two Nikons deliver 24.5 and 36 megapixels respectively so I'm well covered professionally.

For the majority of work for web or projection, and up to A5 print reproduction, a camera with a 6-megapixel sensor will do the job just fine. Most smart phones and tablets also have sensors that have ample cover. Compact and point-and-shoot cameras would also have plenty of file size available for using for web or social media. Again, they may fall short if you decide you want to print from the files.

For projection onto a screen for a presentation, a file size of about 1 MB is usually good enough. In this case the ppi is less important as long as there are enough pixels to cover the screen—usually 1024 across. If it's a vertical image then you need 768 pixels high. With a high-resolution display, such as a retina screen, you must increase the number of pixels depending on the resolution you are aiming for.

Interpolation (sometimes called resampling) is an imaging method to increase (or decrease) the number of pixels in a digital image. It doesn't reproduce well and is not accepted by most photo libraries or agencies as it reduces the quality of the image by adding in guessed or predicted pixels to link up the real ones. If you think you may want to have your picture published at a magazine's double-page spread size, you need a camera that can produce that file size without any interpolation so that the final result will not look pixilated, grainy, or blurred.

Also, if you are sending images to be printed professionally it's important that your computer monitor is colour calibrated so that you and your printer see the same colours or that they match as well as possible. You'll certainly know when the resulting print is not correct, which is especially noticeable in the colour green—of which there are many variations in a garden—so it's really important that you don't accept incorrect results. Currently, professional printers usually prefer image files to be supplied in the colour space Adobe RGB (1998). I set up my own DSLRs in that way from the start to match that requirement. Your camera manual will tell you how. If you are only ever going to want to view your images on a screen, use the colour space sRGB for your JPEG images. It's more generic and works across a greater variety of screens and devices.

MY ESSENTIAL KIT

CAMERAS I own two Nikon DSLRs and I always bring both cameras to photo sessions just in case one lets me down. It's not always the camera's fault though. Over the years I once managed to drop a camera body in a lake, and on another assignment my camera with tripod head spun off the tripod from a height off a raised wooden boardwalk, damaging both lens and body. Accidents do happen, so you can see why it's really important for me to have a spare especially when travelling long distances or shooting an important event.

When photographing botanical specimens, I work with the larger of the two bodies, which has a built-in digital voice recorder that allows me to record correct botanical names in small WAVE (Waveform Audio File Format, sometimes known as WAV) files at the same time when I am capturing specific cultivars or plant species.

Once back home I can replay these files and caption my pictures, adding the information to the metadata. The smaller camera body has different features, including a video option that I experiment with from time to time.

I don't bring it with me on every photo shoot, but the one and only film camera I still occasionally use is a big, heavy Fuji GX 67 panoramic film camera which produces 6 × 17 cm images on 120 roll film. The results are such good quality they currently cannot be beaten by a digital sensor echoing the format.

LENSES To complement my DSLR camera bodies, I usually carry a small range of lenses. Too many large and weighty lenses are a hindrance for travelling, so I've narrowed down the range of lenses that I take everywhere to the ones I use the most often:

- 24–70mm f/2.8 zoom lens (wide angle to portrait)
- 70–300mm f/4.5 zoom lens (portrait to long telephoto)
- 105mm f/2.8 macro or micro lens
- 28mm f/2.8 perspective control lens

FILTERS can create all sorts of effects: graduated filters that put colour into washed out skies, warm filters for when the light is too cool or blue and vice versa, starburst filters that make each glimmer of light burst into a starry explosion, sepia filters to make your image look like an heirloom—and the list goes on. You can find glass filters that screw onto the front of your lens, plastic filter systems that work in a kit form, as well as many post-processing apps.

With the benefit of having tried most filters over the years, I have concluded that I prefer nature in its most natural form. Pure and simple. So these days the only two filters I ever use are a simple skylight or UV filter (to protect my lens from bumps and scratches) and, occasionally, a polarizing filter to eliminate reflections if I can't avoid a lot of flare on a pond or a glass window.

CABLE RELEASE I often keep a cable release attached to my camera for most of the working day. Using it stops any unwanted jarring caused by pressing the shutter release button, even when I am using my tripod. This is really important if you are keeping two or more exposures precisely registered so you can merge them together later in a post-capture application or using a technique such as high dynamic range.

If you don't want to use a cable release for a one-off image you can always use your camera's self-timer, which activates the shutter release when its allowance of seconds or even minutes is reached. This is a good alternative, but it's not ideal if you want absolute precision in registering more than one picture to merge later.

TRIPOD Tripods come in many strengths, sizes, and prices. It's really worth buying the best one you can afford. I find cheap tripods are fiddly to use and do not have enough weight or strength to keep a camera steady at their full extended height. I recommend choosing a tripod that comes with a quick-release shoe that affixes permanently to the bottom of the camera so you don't have to screw the camera to the tripod every time you need to attach or release it.

If you don't have a tripod, get or make yourself a small bean bag. Use it to rest the camera on a solid base (like a stone wall or firm table top) before you take your picture.

REFLECTOR A professional reflector is usually a piece of stretched shiny fabric that snap-folds conveniently for storage. The surface is used to redirect light, such as from the sun, towards a subject or scene. Reflectors are particularly good at filling in shadows in controllable areas when the lighting conditions are contrasty. I use a manufactured version designed in a rounded triangular shape that has a grippy handle at the smallest point to allow easy manoeuvring with one hand. You can choose from different surface options, such as silver, gold, and white, which reflect light in different ways. White is softest, silver provides a colder daylight-coloured reflection, and the gold version gives a warm glow that is helpful for certain skin tones.

If you don't wish to buy a reflector, you can quite easily make your own silver or white one. Simply cover a picture frame with aluminum foil to give a silver daylight effect or use a plain white piece of fabric or cardboard for a soft white reflection.

You may notice I never mention the word *flash*. That's because I don't use a flashgun at all and haven't for many years. I've never used one in a garden environment as I think the result almost always looks unnatural. Some people will use them for filling in shadows, but I prefer a reflector. Or I bracket my images and merge them later to recover details in shadow areas. For photographing botanic specimens or small insects there is a case for using a ring flash, as it gives an even light illuminating tiny details. Great for a laboratory but not something I choose to use for artistic reasons.

DIFFUSER A professional diffuser has much the same make-up as a reflector, but the stretchy fabric allows a certain amount of light through and diffuses (or softens) light onto your subject instead of reflecting it away. This is really useful when photographing plant portraits in bright, contrasty light. Usually I place the diffuser on its own lighting stand holder as I work. You can make a simple diffuser by stapling a piece of greaseproof paper or fine white fabric onto a small, light picture frame.

SPIRIT LEVEL I have a small spirit level that sits snuggly in the hot shoe, the slot where a flashgun would normally sit, on top of my camera. It's especially useful when photographing hilly locations or on challenging terrain when there is often no level horizon to guide me. They are inexpensive and can be easily purchased from most camera stores or over the Internet.

RIGHT-ANGLE FINDER A right-angle finder is a fantastic tool for a DSLR, especially if you are interested in photographing alpine plants or tiny wild flowers. The finder screws onto the eyepiece, resembling a type of small chimney that you can look down through. It is a great convenience that allows waist-level or low-angle photography. Many compact cameras have ready-attached, flip-down, rear-viewing screens that offer the same advantage.

DAYLIGHT LAMP A daylight lamp is a portable lamp that can add a little ping of light to brighten up an image. The bulb is balanced to match daylight so there isn't a conflict of warm and cool light as with the more common tungsten lamps. I don't use this as regularly in my own garden but it is really helpful when light levels are low in the winter, especially to accentuate textures such as bark. My lamp has a battery pack so I can take it with me into woods and arboreta. Sometimes on a very dull day I'll add a ping of light through some leaves to add a bit of interest to a photograph.

GREY CARD Just like it sounds, a grey card is a piece of cardboard or heavy paper in a specific mid-grey colour tone. It can help act as an accurate colour reference, or you can use it with a reflective light meter to produce consistent image exposure. You can buy a grey card from good professional camera stores. Many digital cameras now also have a custom white balance feature making it possible to take a photo of the grey card and then use this data to set the white balance for a sequence of photos. When you are post-processing white balance, you should include the grey card in the scene, as the image-processing software will use the data from the grey card area of the photo to set the white balance point for the whole image. A grey card also is especially useful when shooting a plant if you are trying to accurately reproduce the colours of botanical specimens.

STEPLADDER I often use a stepladder in my photography because I like to have the option to look down onto my subject. Stepladders are also quite useful when it is important to gain some height to remain parallel with the plane of the subject, like the edge of a building or the trunk of a tall tree, to maintain accurate perspective.

KNEEPADS AND GROUND SHEETS These simple gardeners' accessories have become an invaluable part of my kit. As well as taking a bird's-eye view of my scene I sometimes like to get a worm's-eye view as well. I have been known to lie on my tummy photographing wild flowers for many hours. If the subject happens to be on a bed of gravel these kneepads can save a lot of pain.

PHOTOGRAPHIC RUCKSACK A rucksack with many well-padded compartments for my lenses and accessories is essential for carrying my kit safely and securely when I'm on location or travelling. My Lowepro Pro Trekker is always stocked with extra batteries and lens caps, a spirit level, a spare coin for tightening battery compartments, and a tripod quick release.

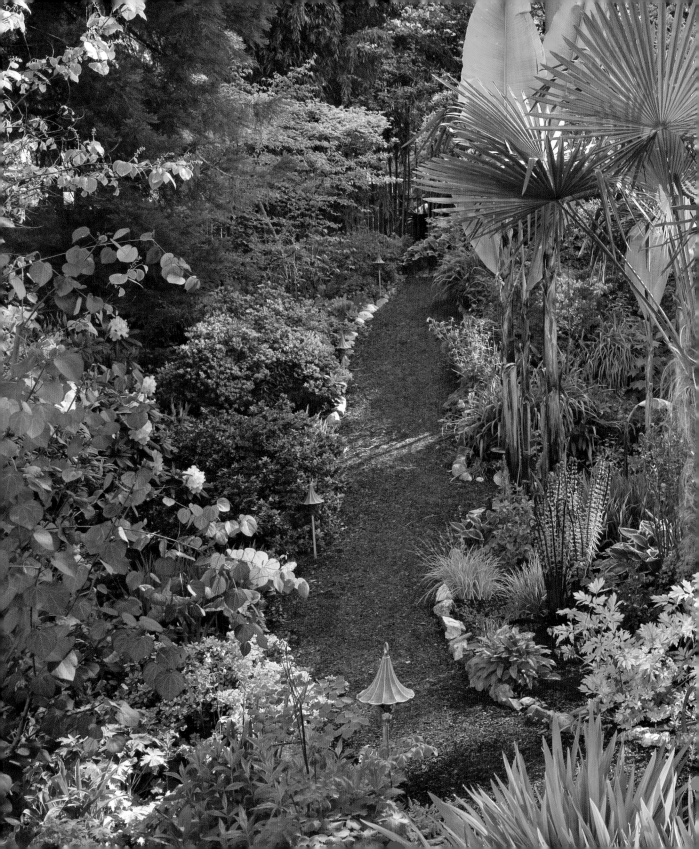

THE GARDEN PORTRAITS

The gardens in this section cover a range of garden styles, on different continents, owned by people of all ages. From the scientific botanist who needs to record and measure to the top professional craftsman with a sharp eye for design, each profiled gardener has different reasons for wanting to capture their garden and varying skill sets and photographic equipment with which to do so.

No matter your level of photography, the everyday challenges you will come across in your own garden—such as harsh light, wet weather, awkward angles, cramped spaces, and vast views—are the same ones that I frequently confront on photography shoots. Here we will delve further into solving these problems, learning new techniques, and finding more ways to enjoy documenting and immortalizing your outdoor space, whether in a print or by sharing on social media.

FINCA VIDA

Creative Composition in Southern Spain

→ *Crafting a garden photo story*
→ *Composing your photograph*

⊙ The restored farmhouse of Finca Vida sits in the foothills of the mountains that rise behind Malaga in Andalucia. I arrived late in the afternoon from a cold and damp Scotland to find dry, red earth and a house with a thatched verandah that wouldn't have been out of place in Africa. Created by Mary and Robert Davis, the garden is filled with thoughtful arrangements of plants and artefacts set against the intense pigments of the landscape and the walls. The task here was to take photographs that captured those artful compositions.

Finca Vida is home to Mary and Robert Davis, who have filled the terrace and garden with artefacts collected during the many years they spent living in Nigeria. Mary, a talented artist, works and teaches from a studio in the garden. With an eye for form and shape, she has created a garden with a strong layout and bold patterns. To capture the essence of Finca Vida, where everything has been placed with great precision and flair, my images had to reflect the confident design.

Mary loves to photograph the garden and uses a simple compact camera. Some of her images are displayed on an "ever-changing screen saver" for her and Robert's shared computer. Other pictures she takes become an important part of her artist's sketchbook, sometimes as a memory jogger when she wants to recall flowering plants in her garden or a layout for paintings or potential redesigns.

CRAFTING A THOUGHTFUL PORTRAIT

Gardens come to life when people are in them, so it is only natural that they should be the setting for photographs of friends and family. Gardens don't just make a colourful backdrop; they are filled with associations of good times and memorable moments, and it is important to include these associations in the picture. A portrait should reveal more about people than just their faces.

An important element to consider when composing a portrait is the rule of odds, the idea that a grouping with an uneven number of elements is more satisfying to the eye than an even number.

COMPOSING A PICTURE

No matter if you are using a basic camera or an expensive DSLR, one important element of taking great pictures doesn't rely on technical skills or sophisticated equipment: developing an eye. As Mary knows well and often teaches in her art classes, it's all about what to include, what to leave out, and how to arrange your chosen ingredients in the art of composition. That might seem intangible, but some simple rules offer guidance:

LOOK FOR LINES I often look for lines in walls, hedges, tree branches, paths—anything at all that can help control how the eye travels across the image. And you don't have to limit yourself just to straight lines. Curves also imply movement and can serve a similar purpose in image composition.

FOLLOW THE GOLDEN RATIO The golden ratio fascinated mathematicians in ancient Greece and has been used ever since to create harmonious forms in art, design, and architecture. Expressed as 1.618, this ratio can be found everywhere in nature, from the spirals of a shell to the centre of a sunflower. It also appears, often unbeknown to us, in the manmade world, for example in the proportions of a television set or a camera viewfinder. The ratio is regularly referred to in photography and art because it provides a reliable formula for good composition. The rule of thirds is essentially a simplified form of this. It's helpful to mentally lay an equally spaced grid of two vertical and two horizontal lines over your composition and check that the key subject areas fall into or sit on one of the line junctions. The viewer's eye will be led into the picture more successfully as the intrigue is off centre.

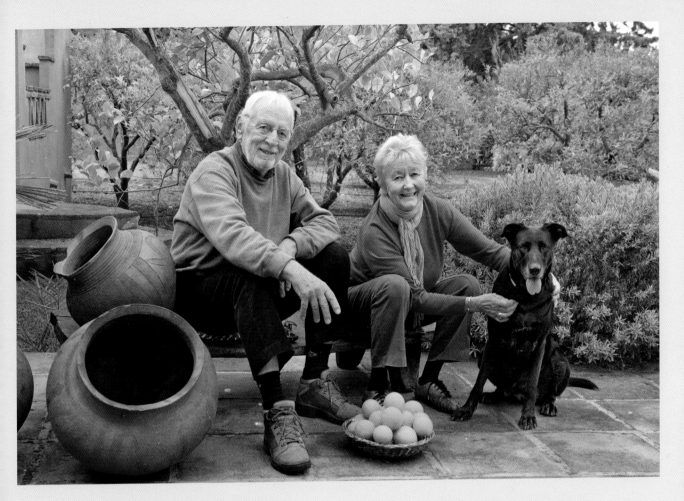

↑ Nothing in this portrait appears by accident; every element should tell you something about the lives of Mary and Robert. When I took this portrait I wanted to set them firmly in their garden, so the bowl of oranges isn't only there to create a splash of colour in the foreground—it also provides a link to the orchard behind them and to the citrus groves that cover the slopes of the hillsides around Finca Vida. It was early February but there had been a drought, so oranges and tangerines were still on the trees.

The Nigerian pots on the left, with their lovely fat, rounded shapes, don't just balance the image, they bring in a flavour of Africa, providing a visual clue to the story of the couple and their garden. It is fun to fill a portrait with subtle hints and associations. Not all of these will be apparent or reveal themselves at first glance, but somehow just by being there they add layers of meaning and richness to the picture.

Tica the dog is an important part of the family. While I would never have left him out, he also helps to satisfy the rule of odds. We waited for some clouds to come over before taking the picture, which helped to reduce contrasty light. Then I used a reflector to direct more light onto the lower shaded area of the image, lifting the shadows from beneath the bowl of oranges and the couple's shoes and trousers, and giving texture to Tica's coat, which might otherwise have become a flat, solid black.

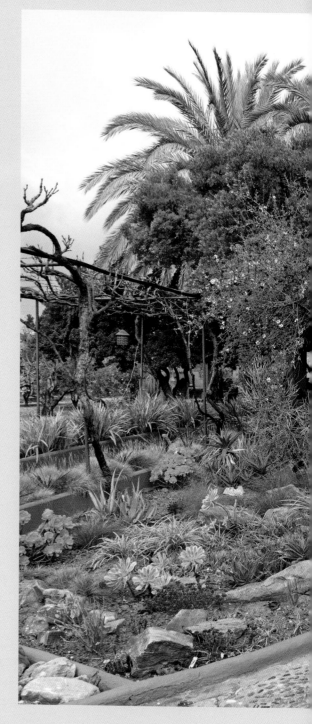

➔ At first glance this picture taken from the path, looking towards the house, might seem to be a very casual shot. In fact, I spent some time carefully selecting where to set up my tripod, considering the angle until I found a spot from which I could use the available lines and curves to give emphasis to the house entrance. I chose this viewpoint because the sweeping curve leads the eye through the photograph. The pergola on the left and the dormant fig tree on the right form converging lines that drew my eye to the door at the end of the path, making it seem very inviting.

You may also see how this picture obeys the rule of thirds by falling into three distinct, equal segments: the path at the bottom, the house and borders in the centre, and the sky and trees at the top. Dividing up the frame in this way makes for a more satisfying image than simply placing the subject in the centre.

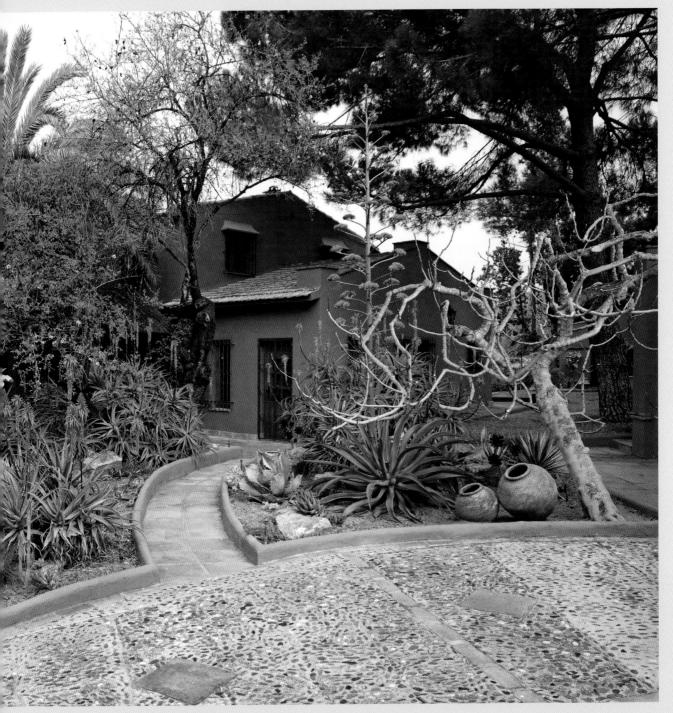

USE DIAGONALS One way to inject energy into a picture is to take it on the diagonal. This works particularly well for linear subjects. For example, instead of looking along the length of a path, you could try angling your shot so that the path enters the frame near bottom left and exits close to the top right-hand corner.

FIND REPETITION You can use repetition to highlight a favourite plant or create rhythm. The work of Brazilian landscape architect Roberto Burle Marx, who said "never make a salad out of your garden," influenced Mary's design of her garden. One way she has followed this advice is by using the same plants over and over again and using similar pots to create impact.

 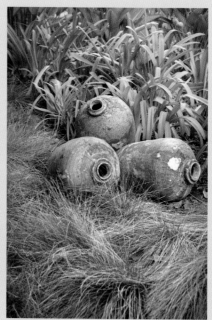

↑ In this image I chose a viewpoint where the edge of the trough forms a diagonal line between the spiky, variegated leaves of the flax lily and the smoothly clipped, round balls of germander, transforming what would otherwise have been just a pleasing contrast between colour and texture into a stronger image. By harnessing the dynamism of diagonal lines you can add energy and life to your pictures.

↗ I used the same diagonal technique to take this photograph of Mary's distressed vintage oil jars set among smooth, strappy agapanthus foliage and fine-textured blue fescue grass. This composition also satisfies the rule of odds. Positioning the jars at the centre of the image might have reduced their impact; by employing the diagonal I broke the rules and it seems to have worked well.

⬆ Repetition is as useful in photography as it is in the garden. Once you start looking for patterns you will begin to see them appear everywhere. If you allow the pattern to fill the frame it can make a very strong image.

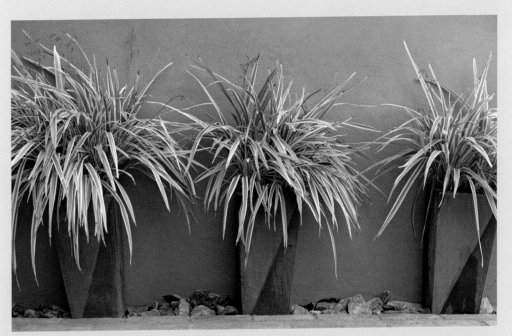

⬆ Mary has used repetition to emphasize one of her favourite plants, *Dianella intermedia*, setting African-style pots against the ochre background.

ESTABLISH EMPHASIS It can be frustrating when photographs don't turn out as you had hoped, especially ones of your favourite plants that were difficult to get a hold of in the first place. Establishing emphasis by choosing what to focus on can help.

CHANGE PROPORTIONS It is easy to get into the habit of using your camera in a fixed horizontal position, but simply by turning it on its side and taking a vertical shot you can change the nature of the image. Some cameras, including my own, have a function which allows a complete change of image area from the usual 35mm specification to 5:4 shape (that of some large-format film cameras) while others may offer different formats such as a panoramic. Sometimes this can help your composition or at least offer an alternative to consider.

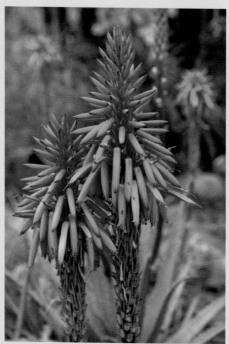

❶ Mary had to wait until she travelled to California to bring this torch lily (*Aloe arborescens*) back to her garden. However, her photographs of the plant were disappointing. Although Mary's goal was "to create an impression of how it looks growing in a group without making the image look confused," she found that the plants in her photograph just looked busy.

❷ I thought about how to help solve this and looked at a similar plant. I found that focusing on just a couple of flowers in this group gave these aloes more emphasis and made a stronger image. I decided to use my DSLR with a 24–70mm f/2.8 zoom lens to photograph the aloes. I used its longest focal length of 70mm and an aperture of just f/6.3 to create a shallow depth of field. I used a tripod and focused the lens on the two flower heads in the foreground. Using a shallow depth of field means that very little beyond what I actually focus on will stay in focus leaving the background quite softened. The blurry flower heads in the background helped frame the subject and emphasize the flowers at the front.

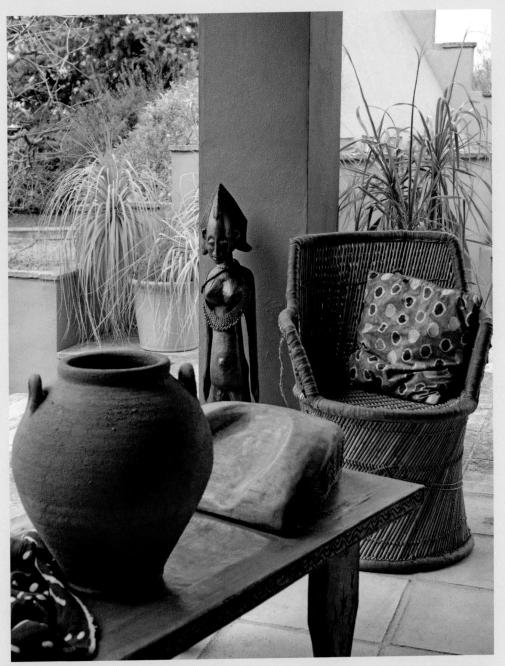

⬆ Some subjects lend themselves naturally to vertical shots. Here the combined impact of the pot, chair, sculpture, and pillar might have been lost if they had been squeezed into a horizontal frame with more of the background showing on either side. In this instance using the camera in the vertical or portrait position makes the grouping appear more imposing.

FRAME A VIEW Framing can turn a simple shot into a composition. It is worth taking time to choose the best position from which to take a shot, looking at your subject from all angles until you find what works best. If your picture appears too busy, try tightening in on the shot to eliminate some of the background clutter.

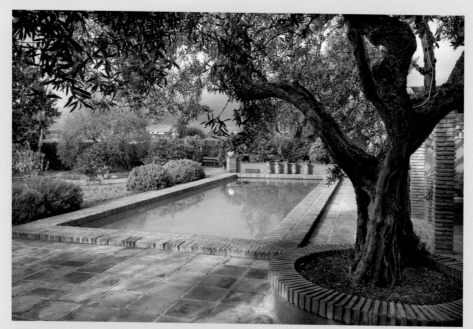

⊕ Few things are more evocative of good times and sunshine than a picture of a swimming pool in southern Spain. I could have concentrated on the pool itself but the picture might have appeared a little flat, so I allowed the lovely gnarled olive tree to form a frame. It proved effective at leading the eye towards the pool, adding to the impression of a hot Mediterranean climate, and providing a sense of scale that would otherwise be missing.

The grey foliage of the olive tree also connects with the colours of the trees in the background, helping to give the photograph a feeling of unity. Framing can also have a practical purpose and here I have used the branches to hide some ugly telegraph wires that would otherwise have been in the shot.

I also believe it is worth taking the time to remove potential distractions, if possible, before taking a photo. Sometimes, with all the advantages of digital technology it's tempting to think that you can clean up the image later by using a software application but I always prefer to capture shots as perfectly as possible in camera. In preparation for the shot of the swimming pool, Robert kindly spent some time removing many fallen leaves from the water's surface. Getting the leaves right before taking the picture is much more time efficient than tidying them up at your computer afterwards, and of course sometimes you may just never get around to it.

⬆ Mary identified an interesting composition of plants on and around her table outside the kitchen, but her photo has two issues: the distracting surroundings and the sharp contrast in the light. Mary has a simple compact camera without an HDR function so tone mapping was not an option.

⬆ I killed two birds with one stone by changing the viewpoint and moving in a bit closer to the subject. I framed it more tightly, thereby decluttering the image and giving the camera a smaller exposure range to measure and cope with, which enabled a good, even exposure. By moving to a different angle I was also able to exclude the pillar from the final image.

PHOTOGRAPHING WATER

An inviting pool or a pond in your garden might seem like a fail-safe subject for a photograph, but it is worth remembering that water, like any shiny surface, reflects light and can be difficult to capture if you try to shoot it in bright sunshine. If you can wait for a little cloud cover or use some other form of shade to diffuse the light, it will help your camera capture the true colours more evenly and intensely. A tripod is also essential for the long exposures necessary for taking photographs of water (as well as other subjects) when it's getting dark.

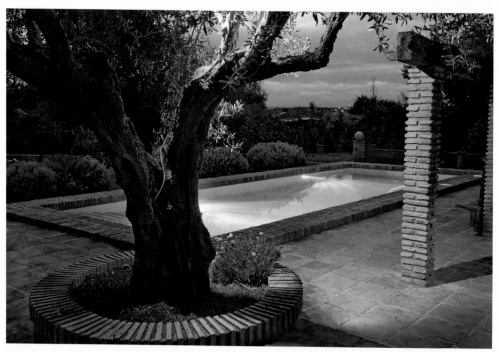

⬆ To capture the night view of their swimming pool, I placed my camera on a tripod and selected a high ISO of 1600 and an aperture of f/8 to create a long exposure of 1.3 seconds. I could have chosen a slower shutter speed—any number of seconds in fact and then I would have been able to reduce the ISO and risk less grain in my picture—but there was a slight breeze and I didn't want to add any further risk of movement in the ripples of water in the pool. I am lucky to own a camera that can cope well with high ISO and not create a lot of grain or noise in the image.

TEXTURE AND COMPLEMENTARY COLOURS IN THE GARDEN

To get the most from a finely textured subject, such as bark, I use a tripod. This holds my camera still and allows me to carefully position and frame an area of particular interest. Also consider using the self-timer switch to eliminate one more risk of movement and subsequent image blur that can occur just by pressing the shutter release button.

Sometimes the tripod acts as an easel for me. I imagine an artist setting up a view, placing an easel, and preparing to work. The commitment of placing the equipment and the time it takes disciplines me to slow down and compose. I look and think more carefully about the area to select than I might do if I were simply handholding a camera and taking a snap.

Trained artists are usually quite familiar with the concept of colour wheels and at least the basics of colour theory. Complementary colours are those that sit opposite each other on the colour wheel and for that reason can jar. However, if the hues are subtle, complementary colours can be simultaneously contrasting and harmonious.

➊ I looked closely before selecting this area of bark and used the silver gilt side of my reflector to add a glint of gold to the surface and lift any unwanted shadows.

➋ Red and blue are at opposite sides of the colour wheel and are known as complementary colours, but in this case the tones of the New Zealand flax and the blue fescue are so muted that they allow a sense of harmony. This explains why the plants stand out from each other so clearly, yet the colour combination remains pleasing to the eye.

NARA

Up Close in a Japanese Courtyard in Dublin, Ireland

→ *Photographing in close-up*
→ *Getting perspective correct*

⊕ Brian Wood created his Japanese courtyard using Shinto artefacts, ancient rocks, and carefully selected plants. Photographing it demanded great attention to detail.

Tucked away behind a traditional cottage on the outskirts of Dublin is a courtyard that perfectly captures the spirit of Japan. In just a few years, Brian Wood has transformed a tiny space into a calm and reflective garden containing ancient rocks, a Shinto shrine, and many small and beautiful plants. I realized that this was a garden where every detail mattered and that close-ups would be required in order to reflect its intricacies.

Even though I knew what I was coming to photograph, I was still astonished to step through the door of a traditional cottage into a vast white room with floor-to-ceiling windows framing a view that could quite easily have been of Nara, the Japanese city from which the cottage takes its name.

GLOSSY LEAVES AND SHINY SURFACES

I believe in the importance of capturing the nature of each plant. In the case of the wild ginger, the curve of the little round leaves and the pattern in shades of blue-green all add to its character. Using a diffuser helps my camera capture the details of a measured amount of shine. I can reduce or increase the amount by tilting the diffuser and moving it nearer to the subject or holding it further away. As with using a reflector, it takes a bit of time and practice to get it just right but by gently moving it around and trying different positions I usually find the spot. I prefer using a diffuser with a handgrip as I find that this is more comfortable and easier to control with only one hand available (the other being on the camera controls).

↻ The leaves of the wild ginger (*Asarum europaeum*) that grows in Brian's garden are so glossy that on a sunny day they reflect significant amounts of light. I knew that if I didn't control this light then these reflections would appear like points of flare, leaving the contrasting dark green leaves devoid of detail. I could have waited for cloud cover, but there was none in sight so instead I used a diffuser to filter out some of the bright light and allow the surfaces of the leaves to appear in all their shiny detail.

Glossy foliage looks best when pristine, so I often use a soft damp cloth or leaf shine wipes to remove unwanted dust or pollen before photographing. In this case the rain did the job for me. Along with emphasizing the glossy appearance of the foliage, the rain also gave a dark, rich tone to the path.

Dust can look unsightly on plants, as well as decks, patios, and paths, particularly in hot, dry climates. Even light rain can sometimes cause unsightly puddles or create a spotting effect. I turn this to my advantage by soaking all the similar areas evenly with water from a hosepipe to give depth of colour and a uniform appearance.

REFLECTIONS AND SHADOWS

The garden's conservatory has been cleverly designed to project out over the pond and Brian lives with an ongoing temptation to throw open the glass doors and photograph the fish that swim below. However, water is highly reflective, bouncing any light from the sky back towards the lens, and can create areas of unwanted white flare.

"The first time I tried it I got a very good picture of myself," Brian explained. Positioning yourself carefully should, in most cases, prevent you from starring in your own picture. If you want to reduce light reflection then you could use a polarizing filter.

To avoid problems with autofocus and light-metering sensors, if you have a DSLR camera you should use a circular polarizing filter (as the beam splitters used to split off the light for focusing and metering are polarization dependent). A circular polarizing filter, which screws onto the front of your lens, is made up of two layers that you must manually rotate until you reach a position where most of the reflections are eliminated—you can choose how much or how little. Currently this effect cannot be created by using software after you have taken your photograph nor is there an app to simulate it. However, tiny polarization filters are now available for smart phones and tablets.

⬆ If Brian had used a polarizing filter he may have minimized the unwanted bright white reflections on the surface of the pond, which spoil the tranquil scene of fish and waterlilies.

⬆ Although reflections are a challenge to photograph, I love that they also provide a chance to be creative. While photographing the fish in the pond I decided to include the reflections of the plants growing around the edges. Making the most of shadows, Brian's fish appear to dart among the foliage like beautiful abstract forms.

Like reflections, shadows also offer the opportunity to add character to an image. Some shadows reveal at a glance the season or time of day when the photograph was taken. Historically, shadows have played a part in creating some of the world's most powerful and memorable photographs. However, guard against unwanted shadows including capturing your own body shape when photographing in sunshine.

SHOOTING AGAINST THE LIGHT

Photographing your subject when facing towards your light source can add drama to your image. It can, however, cause exposure difficulties especially for a camera on an auto exposure setting.

If you don't have a spot metering function on your camera then you can use the exposure compensation dial. Set it to overexpose (+ sign) by a stop or even two, depending on the contrast between light and dark areas. Take a few shots to experi-

⬆ Shadows can be useful and dramatic, but sometimes shadows are not desired as Brian discovered when he caught the clear outline of his own body shape while focusing on this group of primulas. Although clearly not the desired effect here, if you find yourself photographing without a diffuser and in bright, contrasty light, a useful technique is to use your body to reduce the amount of light that reaches a plant or other subject. Just be careful not to allow the light to spill out from around your shadow.

◖ Photographed from below, the golden colours and delicate structure of these maple leaves are revealed. I used the spot metering function on my advanced DSLR camera to create this dramatic shot of the sun shining down through the fanned leaves of a golden Shirasawa maple.

I specifically exposed for the underneath of the leaves to illuminate the ribs and veins. I made the decision to ask the camera to read the details in the shadows of my subject and not the highlights. I was happy to accept that the background of my image would disappear into the light. The compensation outweighed the loss and I was able to capture the intricacies and vibrant golden colour of the leaves and not just their silhouettes.

Here the leaves acted as a diffuser, filtering the light that passed through, giving them a translucent quality and illuminating the different layers of overlapping foliage.

ment using different settings. Some smart phones and tablets may have a similar function so be sure to tap on the area of your screen showing where you want to focus to allow the metering to be as precise as possible.

DETAIL IN WHITE AND BLUE FLOWERS

It is asking a lot of any camera to capture white or very light-coloured flowers on a background of dark green foliage. Brian experienced this problem while photographing his *Camellia transnokoensis*, which is covered in bell-shaped white flowers every January. The flowers, as he described them, "appear as little white blobs against the dark foliage." This is because the colours are from opposite ends of a wide tonal range—a tall order for any digital sensor to cover and it is even harder for the more limited range of film in a film camera to cope with such extremes of highlights and shadows.

↺ In a dark mossy corner of Brian's garden I found this *Beesia deltophylla* and focused my camera on its creamy white petals and stamens. With both a diffuser and a reflector, I was able to capture the details of the tiny star-shaped flowers. The diffuser helped filter the amount of light reaching the flowers and I angled the reflector to bounce the light back where I needed it, filling the shadows and adding details to the newly formed leaves.

I used the RAW setting on my camera when I took this picture, which allowed me some extra exposure latitude after I downloaded the file. I later processed it using the RAW file converter in my computer software.

Using a diffuser and a reflector can help your camera cope with the task of photographing white flowers. Hold the diffuser in front of the sun's rays to prevent some of them from reaching your subject. At this point your plant might appear as if it is in deep shade, but if you are exposing your image using the auto setting, it will adjust the exposure and you will end up with an evenly exposed image. Use a small reflector to help push some light back into your subject. With practice you will be able to aim it exactly where you want it.

Blue is another colour that Brian—and almost every photographer—finds difficult to pin down in pictures. Photographs often don't accurately reflect how we see blue flowers which appear in many cases to be mauve or pink. This is because blue has a shorter wavelength than any other colour in the spectrum, with the exception of indigo and ultra violet, which a regular camera can't register at all.

It is well known that many insects, bees, and birds follow UV-reflecting nectar guides on flowers, which attract them to the most nectar-rich part of the plant. It's the ultra blue that's responsible for giving bluebells their brilliance. However, neither humans nor cameras see the colour in the same way; we view blue with varying degrees of a magenta cast.

One method I've adopted for getting more blue tones into photographs of flowers is to use the blue sky. I photograph the flowers where they are shaded from the side by a tree or perhaps a building, yet are open to the sky above them. In this position the flowers are lit by blue light from the sky, which helps to give them a greater intensity of colour. I also find that photographing blue flowers in the early morning and evening when the sun's rays are lower can improve my chances of success.

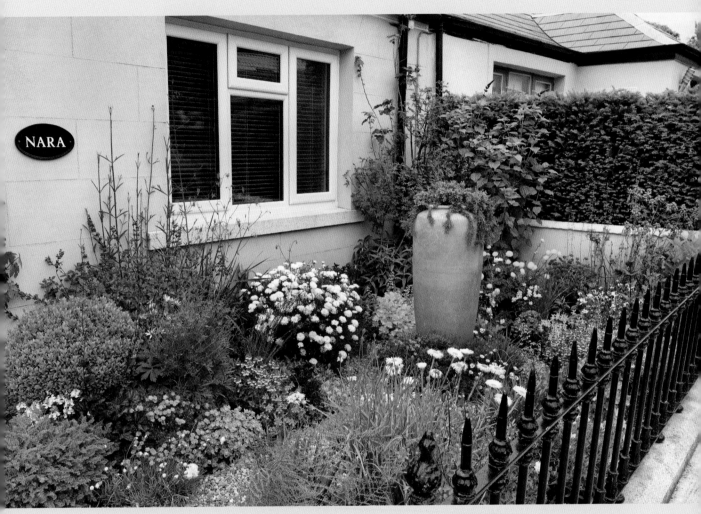

⬆ Brian's tranquil courtyard contains few colours other than green. However, the front garden is a different story, with jauntily coloured flowers clashing together cheerfully against the backdrop of the pale blue wall of his cottage. The blue flowers are among the most difficult to record accurately.

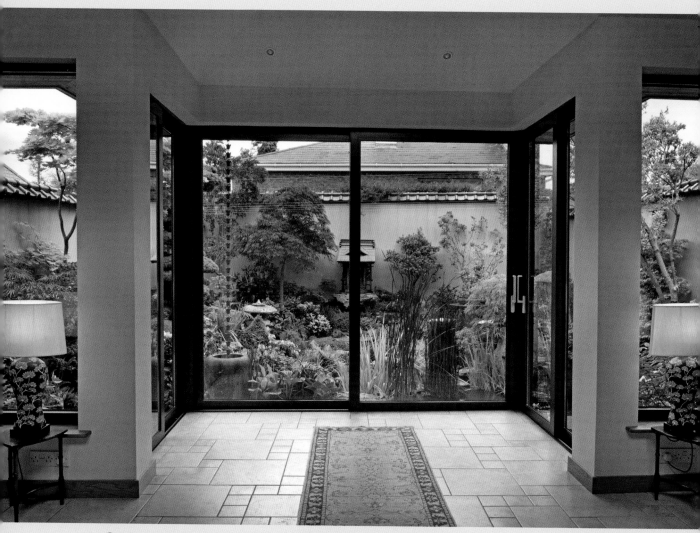

⬆ Brian's garden is square and enclosed on all sides by high tiled walls. These walls, along with the projecting windows of the conservatory, create many vertical lines and horizontal planes that had to be photographed without distortion. When photographing architectural details it is important to consider the perspective carefully and prevent vertical lines from converging.

In order to keep the lines of the panes of glass vertical, I used a short focal length (28mm) perspective control or shift lens. With this type of lens you can move the elements of the lens to a higher or lower position without tilting the camera, enabling you to keep the lines parallel with the plane of the camera sensor and obtain an image that is, in terms of perspective, relatively correct.

THE INFLUENCE OF PERSPECTIVE

Perspective, created by the position, angle, and height at which you photograph a scene, can change the look and mood of a picture. With some subjects in particular, such as small spaces like Brian's garden, it is very important for me to get the perspective correct. Eye level at the average standing position is not always the best vantage point for taking a picture. Kneeling down to look up or standing on a stepladder to provide more height and look down can make for more interesting results although this will certainly change the perspective.

If you are using a standard lens to photograph a building or tall trees from ground level, you may need to walk back quite a long way to fit in all you want while keeping your vertical lines parallel. However, this will often make the subject appear small. If you crouch down and tilt the camera upwards you may get everything you want into the shot but any vertical lines will appear to converge. In this case, you may have to rely on using a wider angle lens while keeping parallel to the subject to keep the image straight and later cropping the image in a post-camera application such as Adobe Photoshop. There are tools and applications available that will also autocorrect for you in post processing, usually called keystoning, if all else fails, but better to get this right in the camera if you possibly can.

Keeping level is crucial. You need to have the plane of the camera sensor parallel to the lines of the subject that you don't want converging. A spirit level can be a helpful tool to keep lines viewed through the camera horizontal or perfectly vertical. You can buy versions made for DSLRs or compact cameras from camera stores. They are not expensive and they conveniently fit into the hot shoe on the top of your camera.

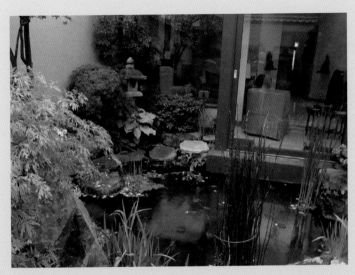

↺ Brian might have benefitted from using a tripod and also a spirit level when taking this picture to keep his lines horizontal.

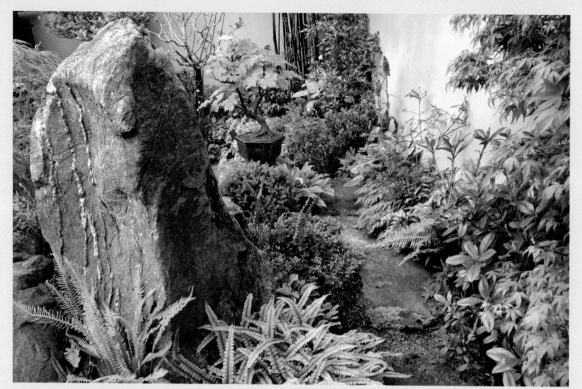

⬆ This narrow path, with foliage spilling over its edges, is typical of the tiny spaces that make up Brian's garden and I was immediately concerned with how I was going to take photographs without stepping on some precious plant or ancient artefact. In a garden where every small detail is a carefully composed part of the whole picture, one shoe in the wrong place could have been disastrous. For the same reason every time I put down the feet of my tripod I looked carefully to ensure that they were doing no damage.

⬅ Every small detail in this garden has been thoughtfully considered so I had to tread carefully in order to do no damage with my shoes or tripod. Covering your tripod feet with bubble wrap or kitchen paper can reduce their impact outdoors. When working indoors I was equally concerned that the beautiful wooden floors would get scratched, so there I covered the feet of the tripod with soft cloth, securing it in place with elastic bands.

MANOEUVRING IN A SMALL SPACE

Finding an elevated position to gain an overview of this garden took some consideration—and a stepladder—and I had to tread carefully among the tiny and exquisite plants.

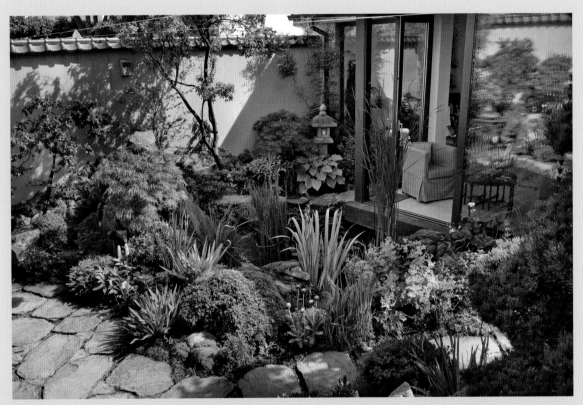

⬆ Elevation was the key to getting this overview of the garden. In such a small, enclosed space, moving back far enough to get everything into shot was not an option, so the only way was up. I used Brian's Japanese stepladder positioned against the wall at the furthest corner and my 24–70mm zoom lens to get the widest possible view with the equipment I had. I captured this image at a focal length of 29mm and an aperture of f/8.

Because I had to leave my tripod at ground level I had no option but to handhold the camera for this image. I fixed my spirit level into the hot shoe on top of my camera before climbing up and used the attachment to check that my camera was absolutely level when I pressed the shutter release button.

SELECTING ORIENTATION

When deciding how to photograph a scene, whether in landscape or portrait mode, I don't just consider the subject and what suits it best, but also the ultimate use for the picture. Brian has to consider this too. Having created such a beautiful garden, it is not surprising that Brian is sometimes invited to talk to local horticultural groups. He illustrates these talks with photographs taken with a compact digital camera and slide presentations look more effective when all the images have the same orientation. This is particularly the case if you want the viewers to make a direct comparison between one image and the next, where a change of format would be distracting.

Plenty of other reasons exist for choosing a particular format, such as if you have a digital photo frame or want to show your pictures on a TV screen. Or maybe you want to submit an image for a background to the weather forecast on a TV channel—then landscape is always essential.

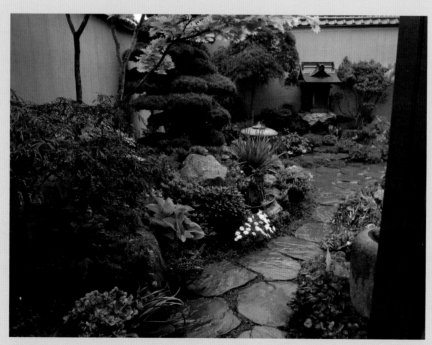

⬆ If Brian had turned his camera vertically when taking this photo, perhaps crouching and moving a bit further to the left, he might have framed this scene more neatly and excluded the ungainly slanting wall in the foreground. However, Brian may have deliberately wanted to use this in a landscape sequence for a presentation, in which case he may have accepted this compromise.

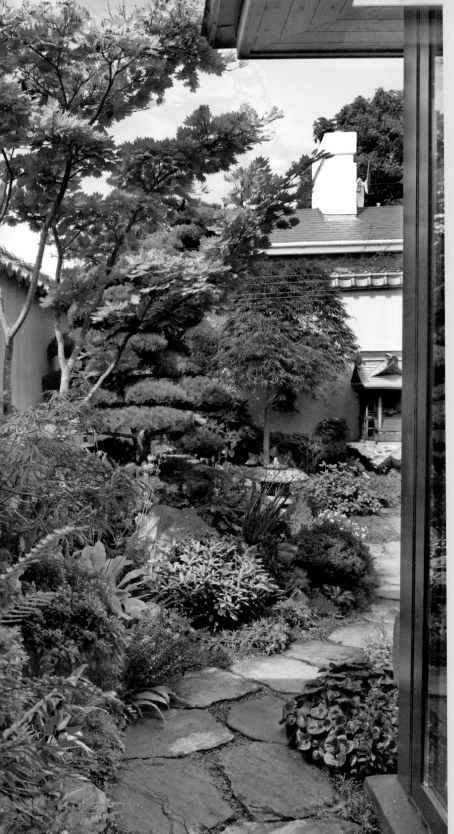

⟳ I wasn't entirely happy with my picture of the same view either—and I had the advantage of a sunny day with passing clouds. I was in a tight corner and literally had my back up against the wall. I would have preferred to show the top of the maple clear of the edge of the roof and not connecting with it. But if I had lowered the camera further and looked up at the scene to give space around the tree, then I would have distorted the image and the line of the edge of the building wouldn't have been vertical. I should have used the perspective control lens that I am lucky to own.

SHOOTING CLOSE-UP

When you see a beautiful flower or fascinating insect on a leaf you may find yourself transfixed by the splendour of this miniature world and want to capture it in a close-up. In a garden like Brian's filled with so many tiny treasures and irresistible details, both natural and designed, I found it hard to know which direction to point my camera.

When something special has inspired you to photograph it close-up, you really want to do it justice. So we can all sympathize with Brian's frustrations with his out-of-focus attempt to capture the striking pink flower of the unusual creeper *Philesia magellanica*. "With my camera I can go in close, to about 18 inches. If I went in really close, as I did here, it would be blurred," said Brian. "With this plant, I sadly failed and as I was taking the shot, I knocked it off the plant so couldn't re-shoot it."

Sadly I have not yet mastered the art of flower repair. However, I learned a rule of magnification many years ago and it works for every kind of camera and lens, including smart phones and tablets. Raise the camera to your eye and then compose your picture, setting your chosen focal length (with the zoom facility if you have one). If you have a DSLR or a compact camera, extend the lens fully. With the extended tip of the lens, almost touch the subject. Resist any temptation to interfere with the zoom facility at this stage or change the length of the lens.

⊙ If Brian had used a simple magnification technique, he would have been able to take a sharp image of this *Philesia magellanica*.

⬆ Practise the magnification technique on a simple subject that is unlikely to move, like this tethered rain chain.

↑ Photographed close-up using a macro lens (105mm Micro Nikkor) for my Nikon camera with an aperture of f/8, the lines and details of this *Viola cornuta* are perfectly clear.

↗ Rain was falling one day when I visited Brian's garden, giving a new layer of interest to the pictures I had started to accumulate. I noticed that the raindrops that had fallen on this sycamore leaf were evenly spaced, creating a distinct, delicate pattern, and that each drop was still perfectly intact. I knew I had to work quickly as each droplet would soon start to sag, lose its grip, and slide off the surface of the leaf to the ground. As we know, planning ahead is not always possible so being able to recognize good opportunities when you see them and being ready to respond quickly is crucial. I took this photograph with my Nikon camera and 105mm Micro Nikkor lens, using an aperture of f/7.1. I also used the gold-threaded side of my reflector to add sparkle and glow to the rain-spotted leaf.

As you pull back from the subject do so very slowly. At first the image in the viewfinder will appear blurry (as it is too close to the subject for the lens to focus) then, at some stage, it will become clear. This first point of clarity is the maximum magnification achievable with your equipment. The size of the subject in the frame of your viewfinder is the largest and most magnified that your piece of camera equipment can achieve.

If I want to reveal the smallest details of a flower I use a macro lens. A true macro lens is capable of magnifying minute details, capturing them on the camera sensor at life-size, which is expressed as a ratio of 1:1 (one to one) or even larger. Twice life-size is written as 2:1. Even 1:2 (half life-size) will allow you to magnify your subject substantially. You can buy additional close-up lenses as accessories for DSLRS, compact cameras, and smart phones to help extend the magnification of your standard lens. Be sure to do your research, as some camera lenses may suggest they are macro but don't in fact reach the desired level of magnification.

SCALE

↩ In Brian's hand, the diminutive size of this miniature hosta becomes evident. This tiny plant belongs to the popular 'Mouse Ears' collection of miniature hostas. The daintiness of its leaves makes it special, so it was important to find a way to underline this. I asked Brian to cup the plant in his fingers in order to give the photograph a sense of scale. Any regular object can be used to act as a measure and emphasize your subject, whether it's a plant as small as this hosta or something much larger. If you were recording growth, then a small ruler or a coin would give you something against which to register progress.

LYNN AND RALPH'S GARDEN

A Mosaic of Moments in Washington State, USA

→ *Making a photographic patchwork quilt*
→ *Editing, archiving, and organizing your photos*

⊙ Although a magical place to spend time, Lynn and Ralph Davis's garden at Crescent Bay posed numerous photographic challenges. The bright light reflected off the bay contrasting with the deep shade of the woodland made their coastal garden more dramatic, although harder to photograph.

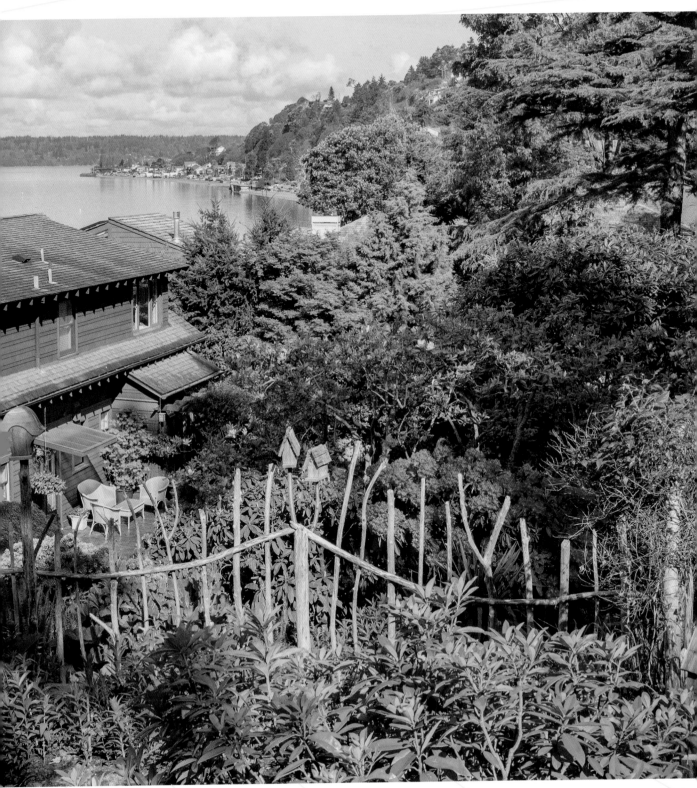

⬆ One of the many paths that wind through the jungly garden to the woodland area provided a strong backbone to this image.

⬆ The only way to capture this area of deep shade and bright light outside the main house was by getting up early to use the early morning light, not a hardship for Lynn and Ralph as while preparing breakfast in their kitchen they can glance out onto the planted terrace and stone patio.

My introduction to this garden on Puget Sound near Seattle came during a working trip to Washington State when Lynn and Ralph Davis kindly invited me to stay in their guesthouse, tucked into the steep wooded slopes overlooking Crescent Bay. I found myself surrounded by lush growth, green lawns, adventurous planting combinations, and splendid mature trees, all interspersed with eclectic artefacts inspired by the owners' many garden tours of Europe. Here was an English-style cutting garden spilling over with fragrant annuals, urns from an Irish castle, and bananas and azaleas cohabiting in a manner that might have delighted the late Christopher Lloyd of British gardening mecca Great Dixter.

Seasoned travellers, Lynn and Ralph often bring both an iPad and a Canon point-and-shoot on their trips to capture their experiences. They have fun mailing out pictures as postcards upon their return. Their garden too is a living scrapbook of memories, as well as a social space with many outdoor dining areas where the couple entertain their numerous friends.

CROPPING PHOTOS FOR A PATCHWORK QUILT

Lynn and Ralph's garden is not an easy space to photograph as Lynn admitted: "Getting a feel of a large area of the garden, getting something close with the trees in the background and large vista pictures—these are real challenges for me."

In my experience, I usually find that positioning myself as high as possible is the answer. However, Lynn and Ralph's house is situated well below the garden, and when the whole property is viewed from the highest point (which was close to a road), the woodland area is almost completely shaded by the trees. This shaded woodland along with the difficult angles of view made it a challenge to photograph as an entire space. Not even my panoramic camera could help this time. I needed another way to capture its essence and beauty, so I decided to create a mosaic of images from within the garden pieced together as a patchwork quilt.

Although I believe it is always better to frame your pictures properly within the camera in the first place, cropping is a valid way of recomposing if you discover a different purpose for an image later. In this case, I wanted to crop my images into square shapes to create the patchwork quilt picture set.

⊕ For romantic reasons, oriental lilies are the favourite flowers of the couple. This image had enough space for me to be able to crop it to a square shape for the patchwork quilt.

Working with my post-camera processing application, I created a more tightly composed copy of my existing processed image file using the Camera RAW filter in Adobe Photoshop's Crop tool. I set the dimensions I wanted for my resulting image that I had already established for each patch, allowing me to leave out the flower bud and give the flower centre stage in the frame. The crop tool enables the user to decrease the width and/or height of a crop marquee and place it over an image to give a new recomposed copy. I used a RAW file which, as always, would remain unaltered by this action. If you were using a TIFF or JPEG file, then be sure to save as a copy with a different name or you'll have lost your original for ever.

MAKE A PATCHWORK QUILT

Using my Adobe Photoshop software, I had such fun making the patchwork quilt for Lynn and Ralph. Firstly, I set up the size of paper I wanted to print on as the end product. Then I measured a space to work on within that having easily divisible dimensions so I could fill it with my 1.5 × 1.5 cm squares. As I intended to print my design after making it, I was careful to keep the dpi setting at 300.

I applied a grid to my on-screen image to help keep the placing straight—just as you might do if you were making a real patchwork quilt. I then selected my images and cropped a square from them one by one. I then copied and pasted a number of versions onto the main image as layers and moved them into the place I wanted. I kept a copy of this file with all its layers in case I wanted to rearrange or tidy it later. When all the squares were placed just right I merged the layers of the image.

I deliberately left narrow gaps between the images so that I could add colour. I added another layer and chose white under the Select menu colour range selector (of the background) and extended the "fuzziness" slider fully. This highlighted all the white areas between the patches, like areas you would apply grout to if you were tiling a bathroom. I then used the "fill" option (under the Edit heading) to apply the colour of my choice (I chose the sky blue from one of the pictures) using the colour picker.

Then to print!

⊕ These images are the fabric of the quilt. I chose carefully so I could crop to shape while still keeping a good composition.

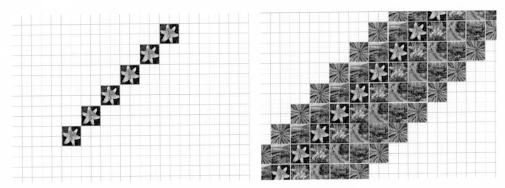

⬆ Making a start by putting down images onto a layer with the help of a grid using Adobe Photoshop.

➋ Layer by layer I repeated certain images in diagonal lines to make a strong pattern and emphasize the colours that I had chosen to make the pattern of the quilt.

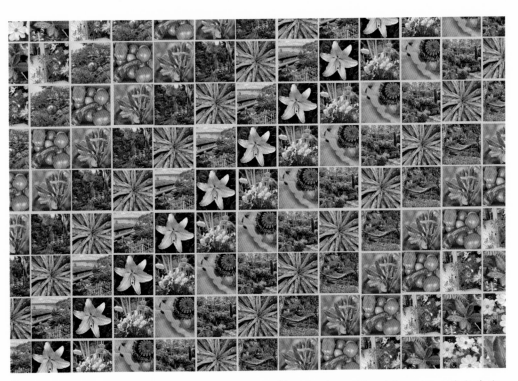

⬆ The finished quilt image prepared. When I was sure I had lined up all the pictures correctly in their layers I merged the layers of the image. All the individual patch images were prepared at 300 dots per inch so that they could be printed on good-quality photographic print paper.

WATCHING FOR GAMUT WARNINGS

The gamut is the range that a digital camera or monitor can display or print. A colour may be within the gamut range that you can view on your monitor—but not within the gamut range of your printer. Your printer will have a limited range of colour inks it can use to create all the various tones it is able to print. When you go to the print function on your post-processing application and click to print, you should see an option for a gamut warning. Tick the box and you may see a selection appear on your picture preview as greyed out. This greyed-out area is out of the range of your printer and will not appear correctly unless you alter your image file. Oversaturation is not always a problem when you just want to view your images online, but if you want to print them later, the printer simply may not cope.

When you are about to print, your software may show you a gamut warning and if so, it's worth checking. In the case of Lynn's tomatoes, the gamut warning showed that some overly bright areas of red were not going to print well. To solve it, use the hue and saturation sliders in your post-camera software application. Check the colour you think is oversaturated by selecting it and then clicking on "red," then push it to the highest point—if the colour blazes then you've got the culprit! Put this slider back to the normal starting point (it's just a checker) and then use the light-dark slider on "red" to darken the colour and reduce the impact slightly. This is a subtle way of keeping the best colour without losing it in your prints. Resist the temptation to simply reduce the saturation itself as you'll lose the quality of the colour tone. I don't recommend altering the hue either as you'll start changing your colours completely.

When you've done that try to print again and the gamut warning should have disappeared. You may need a little trial and error here to get it right. You'll still have bright red fruit in your image but with the full range of tones. This is something to watch for with all colours and can be the route of many printing issues whether you are home printing from your computer or sending your images to a print company to reproduce for you.

EDIT PICTURES BEFORE ARCHIVING

Editing is a necessary process. You simply can't keep them all. Edit down your photographs carefully but decisively so that you don't fill up drive space needlessly with similar versions of a picture. It's a very good discipline to learn. I would admit to not being as good as I would wish on this point, so do as I say and not as I do. I find it hard to make the time to go through the results of every photo shoot and scrutinize as rigorously as I should. The penalty is bigger and bigger hard drives and their financial cost.

Lynn explained that she deletes a lot of pictures when editing because it makes it so much easier to find what you are looking for if you get rid of the "iffy" stuff. She uses iPhoto and finds that this application works well and satisfies all of her editing needs.

I use an Adobe application like Bridge or Lightroom. Normally I start at the end of my file list and edit backwards. The reason is logical: when I photograph a scene and take several versions, the last exposure is usually the best. That's when I know I

⬆ Lynn had picked these gorgeous, colourful tomatoes and peppers from her garden and arranged them in a dish. This combination of reds was irresistible to capture, but when processing the final image I had to be careful that the red colour wouldn't become oversaturated and therefore unprintable.

Most colour printers cannot match the brightly backlit colours we are used to seeing on our various display screens. Be careful that you watch the gamut warning (as in the lower photo) for too much saturation in the print box if you are printing yourself at home as otherwise you may not get the result you expected.

have moved on to photograph another subject in my photo shoot. So it makes sense to me to look through the list from back to front so I see the likely best image first and know to delete the others. Before I delete anything, though, I open files in Photoshop and look at them at 100 percent resolution. This is the only way to see correctly whether an image has a problem. If, for example, there is camera shake, then it might render that image useless for my job and I may as well dispose of it. Artefacts such as dirt or grease spots in the shot would not necessarily put me off a good image as I can usually retouch it later, but I would not keep an image where the focus was soft or blurred unless this was deliberate.

CAPTIONING AND EMBEDDING INFORMATION

When I'm working on a location shoot, it's very important for my job to be able to confirm and record the correct botanical and location names to then pass on to my editors or writers. Whether the pictures are for our photo library stock or to go directly to a commissioner I must record this information accurately. Reliable information is crucial to my work.

Equally, you may want to record the names of plants that you have spotted while visiting a garden that you think could work well in your own border next year. Or you may just wish to have a record of your own plants when you first planted them as bulbs or sown seeds.

Lynn and Ralph are great friends of the team who work at Great Dixter where tradition dictated that staff were not to use plant labels in the gardens. The late Christopher Lloyd was insistent that all of his staff should learn their plant names by heart. Until recently I believe this practice even extended to the nursery and sales area where assistant gardeners would always be available to help—but no plant names were ever written. The idea was to encourage everyone to learn and use correct plant names. Lynn echoed this sentiment for aesthetic reasons: "I don't like looking at name tags in my garden!" I confess, neither do I. Sadly, we haven't all got such good memories that we can remember every plant or accurately guess every plant name—so here's where cameras can help enormously.

If plant labels or seed packets are available then it's worth taking a quick shot in the next frame to remember which species or cultivar you have just captured. A drawback of this method is that each file will be the same size as the image which will soon help to fill up your device's memory and computer hard drive space. If you have a DSLR and can swap between RAW files and low-res JPEGS, it's worth making the change. Just remember to switch back again afterwards. Alternatively take a second snap with your smart phone if you have one.

My Nikon DSLR can record voice memos up to a minute in length as WAVE files. It then tags them with the particular file I am currently previewing on the camera's small display screen. This comparatively tiny file helps save valuable file space. I feel fortunate to have this facility and wish it were available on more cameras.

⊕ Lynn photographed this flowering 'King George' rhododendron and noted that it is one of the only scented varieties of rhododendron—useful information to record with her files. I think there is a lot of detail in this white flower so Lynn did extremely well, but when photographing in contrasted light such as this, I might have used a light reflector that helps greatly to fill the shadows.

For many years previously, I made copious handwritten notes and filled many notebooks. I have labelled each notebook with the date it started and finished, and each page is dated and labelled with the garden I visited. Now I have several shelves stacked with these books—the notes are still a valuable reference source, so it was worth making the effort.

Having gathered all the correct information you want, how do you embed it into your own image files? All digital images are capable of storing information or metadata within their file. Metadata was the name assigned historically to the card catalogues used by reference libraries and today it describes the information about the subject stored in a digital file. It should always include who took the image (the author) and to whom the copyright belongs (in the United Kingdom, the U.S., and Canada the law dictates it's the photographer unless by agreement with another party). Automatically most digital cameras will also include the picture file size, the image resolution, and when the image was created, among other basic camera information.

My own method of entering information into my pictures is currently to use an application such as Adobe Bridge or Adobe Lightroom. Usually when images are viewed within this application, a number of tab options are offered that include the heading Metadata and a further subheading, IPTC Core. In IPTC Core I can enter data including the plant names, the location, and my copyright, and then I can choose to apply that information to one or all of the images I've highlighted.

Normally digital cameras will automatically record time and date of image capture as well as any information about the camera and lens used, plus the aperture and shutter speed that recorded the image. This information can be found in the EXIF (Exchangeable Image Format, referring to metadata) category.

Images on web pages often include metadata in the form of meta tags or keywords, which commonly describe the web page content. This is how pictures are found again and most search engines use this data when adding pages to their search index. You can use meta tags or keywords to help find your own archived images through your computer search function (Finder on Apple Macs) by entering appropriate terms such as "Lily, white" if you are looking through your files for a white lily. You can also search this way using most photo-editing software applications. When you have entered your metadata be sure to synchronize it with the file. Each application will have a different way to do this but it's crucial to remember.

BACKING UP AND ARCHIVING FILES

Memories are precious. Imagine how you would feel if your grandparents' old photographic prints were destroyed in a house fire. I am sure you'd feel that same sense of loss if all your digital images were only stored on your computer hard drive and that crashed. Failures do happen, and quite frequently too. Occasionally if you use a recovery programme or take the computer to a specialist you may be able to retrieve your files—but this is not guaranteed and can be expensive.

The good news is that avoiding this heartache is neither difficult nor too costly. For simplicity, you can purchase inexpensive large-capacity portable drives; many software programmes (after installation and set-up) will automatically back up your files when you attach your drives to your computer. Another option is storing your files remotely within file hosting or file storage services such as Dropbox or Google Drive or a subscription service such as iCloud. However, keep in mind that accessing files again quickly can depend on the speed of your area's wireless network. Personally I prefer to work with terrestrial drives for the moment because of the large number of files I have to store.

Archiving files so that you can find them again takes a little bit of discipline but when you understand how it works, it's easy—just remember to stick with it. Let's assume you have all the basic equipment you need to create an archive system: a desktop computer or a laptop, a couple of empty portable hard drives (one for a

backup), and the software that came with your camera to allow you to download your files. I don't ever keep my images on the hard drive of the computer itself as it is an attractive object for thieves and can crash and corrupt files, and the files take up space on your hard drive. I only ever use the computer as a tool to download the files. The key is to direct the camera files into a folder of your choice on the hard drive and organize the folders well.

When the software opens it will usually allow you to specify where to send the files and to name the folder they are entering. I date my folders in reverse and might add a short name, such as 20150610_Front Garden (year, month, day backwards, plus a name that simply describes the location of the group of images), avoiding using any punctuation marks. By dating the folders in order with the year first, each subsequent chronological folder will then line up from first to last if you were to view them as a list. As long as you know where your image file folders are stored, the date, or their name, you can find them again by searching through the directory of your computer or by using a photo-editing application.

As a rule, when I'm working on location I take two small portable hard drives with me each with a 1 TB capacity to which I back up all the RAW files from my camera each evening to one and then copy to the second, creating identical copies. I then keep one drive in my hand luggage or camera bag and the other I tuck into my suitcase with my travel clothes. Should one get lost if I am flying, I'll always have the other safe—unless I am extremely unfortunate! I do the same when travelling by road as you can never be sure what's going to happen. I often use my laptop in a coffee shop and although it has never happened to me (fingers crossed) I have heard dreadful tales of colleagues whose equipment has been stolen when they quickly looked the other way. Over the years on very special assignments I have sent a third copy to my studio by courier.

When I return back to base, I download one of those image sets only to the main hard drive of my library's archive. The camera will have automatically given each image a file name or number; I always keep that and add a unique sequential number as well through a cataloguing programme. Adding captions and keywords comes later.

For my main archive, I have three stand-alone but identical enclosures (or boxes) that are able to support much larger drives, programmed to regularly and automatically back up to each other. This system allows me to have both a nightly backup of new images that I have added or worked on during the previous day and an offsite weekly backup so that if the worst happens, I can restore my library archive without much delay or expense.

This all probably sounds a bit overcautious, but why not consider keeping one copy in a safe place in a coolbox to protect it from extreme temperatures in the garage, greenhouse, or garden shed? It's always good to have a backup offsite.

LOOKING BACK AND LOOKING FORWARD

Reflecting over photographs from the past year helps Lynn and Ralph remember what looked good in the garden as well as what they didn't like. "You lose something when you don't have an actual photograph," Ralph remarked. "We don't have the same quality of record as we did when everything was printed and I miss that because I don't use a computer the way Lynn does." Every year, Lynn explained, she makes a calendar of garden pictures for Ralph, starting with snow in January and then moving on to bulbs and snowdrops. "I capture each month throughout the year, including the 42 hubbard squashes around the house for Halloween, and put it together for Christmas when we have 15,000 lights in the trees."

To make your own calendars and cards you can simply create your own prints and mount them on traditional blank cards. Otherwise there are multitudes of online printing companies who offer photo books, albums, and a countless array of other options. Usually, the website will give you the ability to determine the style and the layout of your chosen product from a set of existing templates—then just upload your selected processed files directly. Most sites have clear instructions and make it easy for you. It's fun to do and the results are usually surprisingly good. The hardest part is just waiting for the results to arrive.

PHOTOGRAPHING SCULPTURE

Regarding the sculptures in their garden, Ralph explained that they don't go looking for art, but when something speaks to them, they bring it home. "Pieces of art have selected us and then we have to work out where to put them. Sometimes we move them because of the time of year or a special memory."

I take great care when photographing sculpture—after all it's someone else's artwork—and I always try to respect that and show it to its best advantage. Lynn and Ralph had placed this sculpture among a background of colourful plants so I walked around the piece, carefully choosing the best angle. Much as if it were a specimen tree in full flower, I waited for a light cloud and used my reflector to add a highlight showing its form. Although the texture of the foliage enhanced its smooth finish and the colour of the bright azaleas reflected in its curves, in this case the plants had to take a supporting role so as not to hide its character because as Ralph concluded, "All of our artwork brings back special memories."

↑ Lynn has composed a great picture of her hubbard squashes with pretty lighting for Halloween. It will help her next year when planning another display to be able to look back. Making sure you can find those pictures next year is why good archiving is vital. Perhaps also next year a tripod might help such a shot; note how just the tiniest movement has caused the lights to blur. In this case it's really quite pretty and similar to a desired blurry quality called the bokeh effect.

↶ Ralph prefers to be in the garden rather than behind the screen of a computer. This garden is a lot of physical work for him, but it's also about reflection and observation. In Ralph's words, the whole garden for him and Lynn is "a great vehicle for solid connection and putting two people together" and "the photographs help us share those memories." Taking this photograph with Ralph's comment in mind, I wanted the trees to frame the scene with Ralph's hammock. This allowed the background of flowering shrubs to give a sense of space and context. I used my stepladder to give me some height.

↑ Just as every picture tells a story, so does every piece of art for Lynn and Ralph Davis. In this case the sculpture takes the stage. I looked for an angle that used the light and the plants to enhance the shape and form.

PARKHEAD

Working with the Elements on the West Coast of Scotland

→ *Capturing winter weather*
→ *Creating slide presentations and photo books*

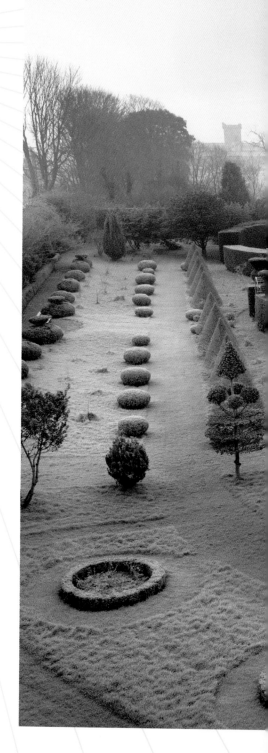

◑ It took me two years and many failed attempts before I succeeded in capturing Parkhead glittering under a cloak of thick frost. Over that time I scanned the forecasts continuously and dashed north whenever the temperature dropped, only to be defeated by the North Atlantic Drift that sends water from the Gulf of Mexico up the Clyde estuary to where it can flow into the sea lochs that surround the Rosneath peninsula, lifting temperatures and making frost a rarity. Careful planning with owner Ian McKellar's help and attention to weather forecasts made it possible.

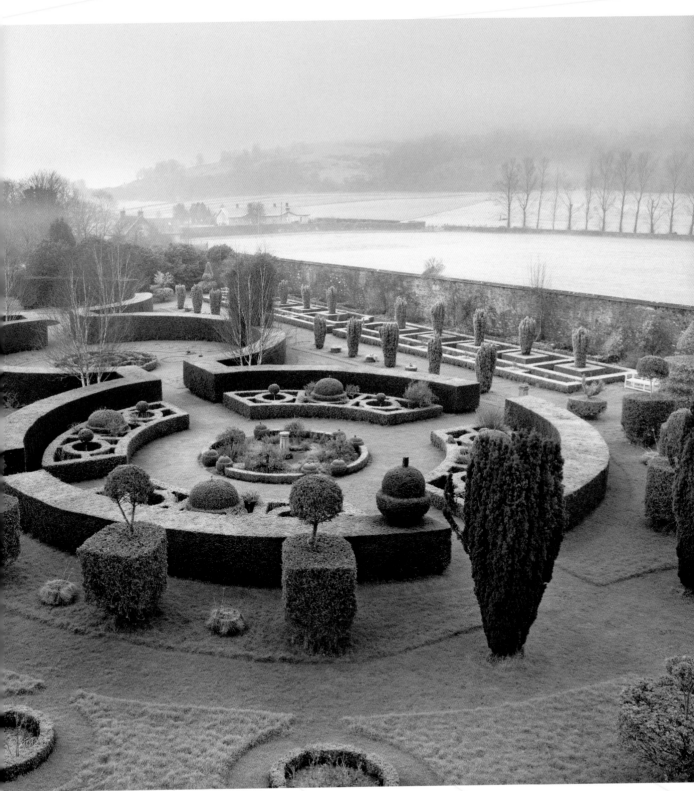

Mention rainforests and your thoughts probably turn to tropical climates, but the west coast of Scotland is the unlikely location of some of the world's most fascinating rainforest environments. These are temperate rainforests, Atlantic oakwoods, where temperatures rarely reach freezing and mosses and liverworts flourish.

It is here in Argyll that Ian McKellar has created a formal garden of astonishing precision over the course of more than thirty years. I had heard about it from several sources but it was only on seeing it that I appreciated its brilliance. Within the confines of an eighteenth-century walled garden, curved at the ends like a bagatelle board, Ian has made a masterpiece from box, yew, and holly.

Immediately it struck me that this garden truly came into its own in winter, when the topiary shapes cast long shadows and grey skies intensified its graphic nature. Winter in this part of Scotland is the season of fog and mists, low sun, high winds, plentiful rain, and on rare occasions, snow. Finding ways of predicting and using these climactic conditions became part of the exciting challenge of doing justice to Ian's creation.

Ian trained as an architect and his love of architectural plans has shaped Parkhead. He has photographed it at many stages and in all seasons using a Canon Digital IXUS 70 and a cherished Voigtlander film camera. He has an eye not just for poetic moments, such as when a butterfly alights on a flower, but for more prosaic events too, including the sinking of a new septic tank. Recently the decision to put the home and garden up for sale has spurred Ian to take fresh images for a private book that he and his wife, Susan, can take with them when they leave Parkhead for good.

CAPTURING WINTER WEATHER

Garden photography depends hugely on weather. When planning photography shoots I keep a close eye on the forecasts, taking note of three separate predictions and averaging out the results. It's just the same with your own garden: keep your eye on the weather and be prepared. If you are in the know then you may be able to book a day off work or change plans in advance to be home for those atmospheric moments. Winter weather—frost, snow, and mist or fog—poses unique photographic challenges as well as opportunities. Developing an understanding of it can help you to anticipate when it will be at its best and how to adapt when conditions are less than ideal.

FROST The "hoar" in hoar frost comes from an Old English word that describes showing signs of old age; in this context it refers to the frost that makes trees and bushes look like white hair. The difference between hoar frost and rime frost is how the ice crystals form. A hoar frost develops when water vapour freezes, going directly from a gas to solid, whereas rime frost forms when super cooled liquid water droplets freeze on contact with cold surfaces.

Frost looks wonderful when the crystals are pin sharp, but don't be tempted to oversharpen the image using a post-camera application. If I sharpen anything at all, I look at the image at 100 percent magnification on my computer. Otherwise the sharpening tool (which only ever gives the illusion of sharpening) can make the edges have an unfortunate haloed effect like tramlines or train tracks.

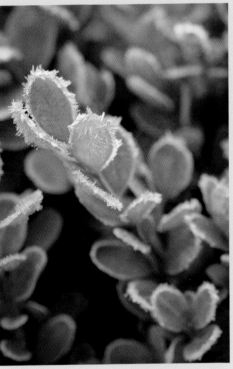

⬆ Frost occurs in different ways. Here the metal of the sundial was colder than the surrounding air. When the water vapour in the air touched the ornament, the moisture froze and crystals formed, accentuating the beauty of its detail.

➲ Photographing close-ups with frost can make fairly plain leaves look otherworldly. To achieve this effect, if you have a DSLR extend your close-up lens to maximum magnification to capture the details of the spiky little crystals. If photographing with a compact camera or phone, use your macro setting.

Sometimes when you are photographing in frosty conditions it helps to use a small reflector (or even a piece of aluminum foil) to reflect light into the shadows and enhance the image.

SNOW How cold does it have to be for snow? Surprisingly not as low as the freezing point. The heaviest snowfall often occurs when the air temperature is between 32 and 35°F (0 and 2°C). If the temperature is warmer than 35°F (2°C) then snowflakes will melt and fall as sleet, and if it's warmer still then the precipitation will fall as rain, which is not often something we want to photograph.

Snow can appear blue in pictures when it is receiving no direct sunlight but is simply being lit by the sun reflecting the blue sky. To eliminate the threat of an unwanted blue cast and give a neutral tone to the snow, I'd recommend setting the white balance feature on your camera to auto. That will usually get strong colour casts right at the capture stage. The white balance control helps ensure that neutral colours are captured accurately. Simply, we need to be sure that our pictures look as if they are illuminated by white light and not tinted with another colour—unless that's what we intend.

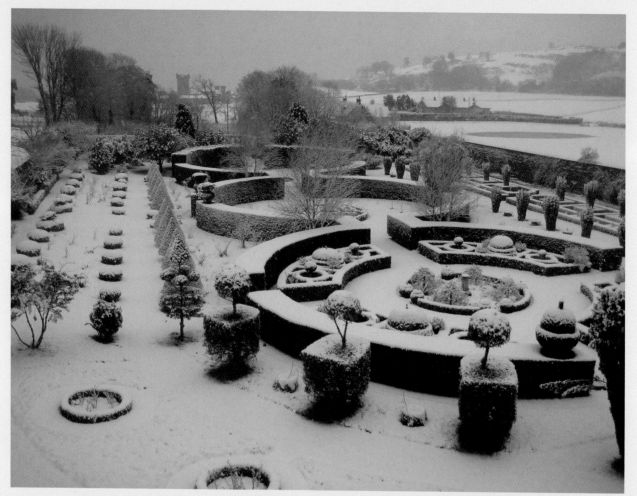

⊙ Photographing during a snowfall can be magical, but sometimes it can be a bit dark and gloomy as in Ian's own photograph from the attic window. I usually wait until the snow has stopped falling and the sky clears, and then I hope the sky will turn blue. However, in this instance, the tones of grey added layers of texture to the cold, bleak atmosphere. If Ian had wanted to lighten the monochromatic look a little he could have overexposed by one f-stop. With a manual camera I would certainly recommend opening up the aperture by at least one extra stop to lighten the look under these sorts of conditions.

You can also colour correct an extreme blue cast in-camera by taking a preset or custom white balance from the snow. If you use a more sophisticated DSLR and photograph in RAW you could leave that until later in post-camera processing and not worry about it at this stage, but personally I'd rather get it right in the camera and spend less time correcting casts in front of the computer.

If you use post-camera applications such as Adobe Photoshop then a quick way to colour correct an image is to use the dropper tool. Select an area you know to be neutral grey. Click on that point and the software will sample the colour data and adjust the whole image so that the sampled point is neutral. In effect it relates all the other colours to that neutral colour, rendering the whole image colour correct. If you do not have a neutral grey in your photo you can also use the dropper for black or white to achieve the same results.

MIST AND FOG Fog and mist lower the contrast of your surroundings and mute colours in a way that would be hard to achieve with any kind of post-camera processing application. The difference between mist and fog is visibility. On foggy mornings visibility is reduced to less then one kilometer, or a little over half a mile; mist is lighter and does not reduce visibility as much. One benefit of misty or foggy mornings is that they extend that golden hour, offering more time to enjoy and photograph the muted light.

Because of the layers of atmospheric density, exposures will become longer. Use a tripod if you have one. Watch out for any movement during long exposures, such as branches or long wisps of grasses that move in the breeze and could appear blurred. If you are using a camera with a manual override, use a shutter speed faster than the movement, say $1/125$ of a second, and if necessary increase the ISO rating to accommodate this. In order to prevent the sky from becoming dark and gloomy or unwanted silhouettes from forming, open your lens aperture up a stop.

PHOTOGRAPHY ON THE COAST

A note for photographing in coastal regions: whenever you get a combination of salt water and winds you'll notice that before long you'll have a film of salt on the front element of your lens, so be sure to keep your lenses covered and clean when you aren't using them. Otherwise they will soon deteriorate, another good reason to use a protective filter.

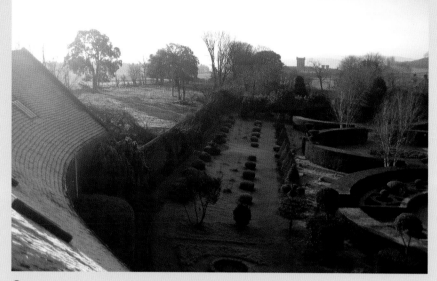

⊕ Ian took this picture on another occasion after a light layer of snow had fallen. Photographed a little later in the morning when the sun was higher, the colour in the sky has become whiter, the contrast is greater, and the shadows deeper.

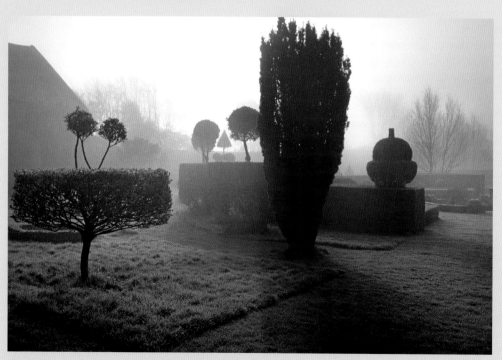

⊕ Shadows can help define sculptural subjects such as topiary. With my camera on a tripod I pointed it towards the topiary in front of the sun which was trying to break through the mist. Thanks to the mist acting as a diffuser of the sun's rays, I was able to capture detail in the yew tree in the foreground and the tree beyond too.

SKY AS THE MAIN SUBJECT

Sky isn't always the backdrop to a photograph—sometimes it's the main event. Variable weather creates landscape images that are more fun to capture than endless blue skies. Skies full of cumulus clouds, shafts of sunlight, and rainbows, dramatic dark skies filled with heavy rain clouds, or colourful sunsets and sunrises can make a picture in themselves. So don't be put off if your weather forecast is not full of smiling sunny icons.

A visual anchor of some sort, either land or sea based, is a good compositional ally but the larger proportions of the image will give the sky the centre stage it so often deserves. As much as two-thirds sky and one-third base can work, or be daring and go even more extreme. A wider-angle lens allows you to include more of the sky, which can really help exaggerate the effect of big brooding clouds. It can also change the perspective and give the feeling that the clouds are rushing towards and around you and your camera.

↪ Ian's beautiful photograph has a Turneresque quality. The yellow light over the house gives the appearance of an old master oil painting with yellowed varnish. It could be a yellow cast and accidental, but could you reproduce this effect if you wanted to? It's worth trying to achieve with a warm tint in a post-camera application.

PARKHEAD

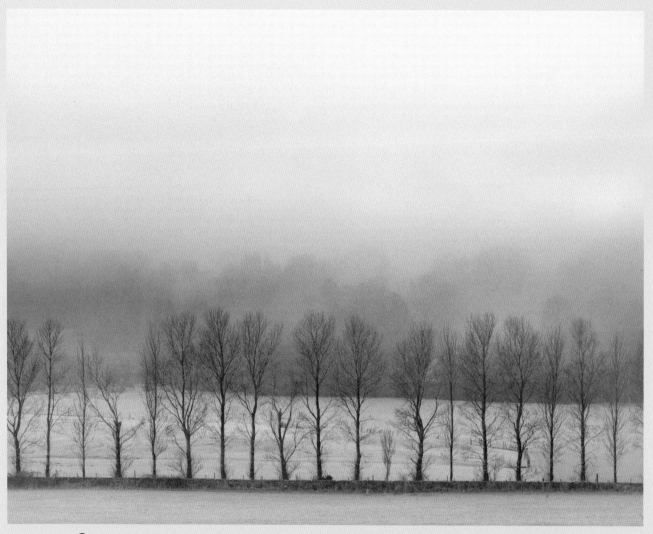

⊕ The larger proportions of sky to land emphasizes the moodiness of this misty moment. The regular line of the trees provides the anchor for the eye.

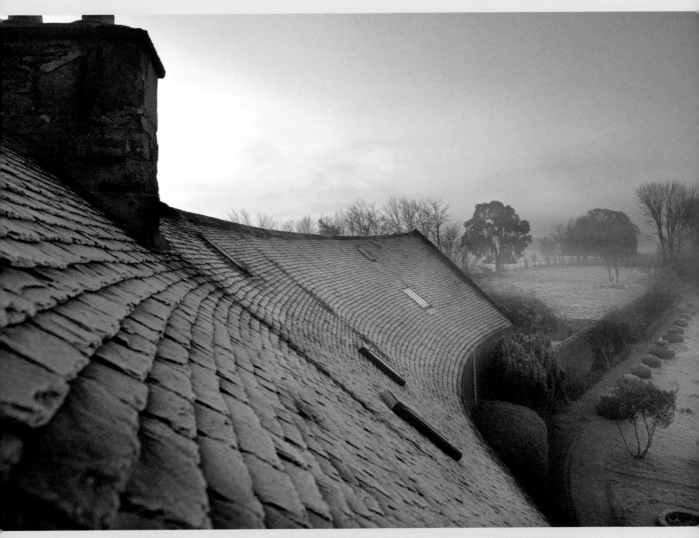

🔾 Early in the morning we tiptoed up to the loft area inside the house where Ian had positioned a rickety ladder and I popped my head out the skylight window. The light was still low but it was freezing and the sun began to rise in the distance. Ideally I would have used a tripod to capture this image, but without a steady base to place its feet I firmly wedged my camera onto the lip of the window frame and leaned against it to hold it steady. I used a high ISO rating of 2500 to obtain a shutter speed of ¹⁄₁₀₀ of a second at f/6.3.

HAVING FUN WITH SHADOWS AND PATTERNS

Without shadows our photographs can look flat. Shadows are often treated as the enemy but they can be used to great effect. Sometimes I can camouflage myself and my camera on the tripod by hiding in a shadow. Shadows help define sculptural subjects such as topiary. Long shadows can give great drama to a shape.

When using natural light as the light source for a shadow, you need to position yourself high up and shoot down on it. The tricky part is that any structure that you use to get up high will itself cast a shadow so you need to ensure that your subjects are on the side of the structure that is not in shadow.

Patterns and repetitive shapes can be great fun to play with. A small section of repetitive shapes forming a graphic pattern can give the impression of far larger numbers if you move in close and allow the repetition to fill your frame.

Iced-up puddles can form fascinating and abstract patterns so let your imagination run wild when taking photographs of them. When photographing ice I find it useful to set my camera on a tripod, carefully aim it straight down, and then select the pattern using my zoom lens.

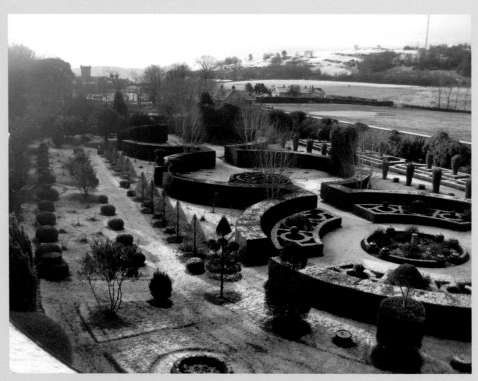

⊙ When using natural light, photograph from up high to capture the strongest shadows. Ian used an attic window to get this aerial view.

⬅ ⬇ Repetitive shapes can give the impression of a journey to eternity. Ian's precision-cut hornbeam cones march towards the house and other topiary shapes. I could have used a zoom lens to close in on the frame and further enhance the effect. I got a similar effect with the golden yew trees and box hedges. In both cases the mist accentuates the illusion of the trees disappearing into the distance.

⬅ The patterns and concentric rings of icy puddles make great material for abstract images.

FRAMING

Some things look better when set in a frame, so I am always on the lookout for frames to enhance my subjects. An overhanging tree is ideal and the leaves can soften the edges of a picture. A gateway in the foreground can also help lead the eye towards the main subject.

🅧 I often look around for overhanging foliage to make a frame for an image. Here, a tree frames another tree.

🅨 The open gate with a path and steps in the foreground helps to lead the eye towards the pink light of the early morning sun.

CREATING SLIDE PRESENTATIONS

As word about Parkhead has spread, Ian has frequently been asked to give slide presentations about its creation. If you know in advance that your pictures might be used for a slide show then I recommend bearing a few things in mind while you are taking photographs.

Photographing all of your images the same way (either vertically or horizontally) can be a difficult rule to follow, but it will make for a smoother sequence and the transitions will be much easier on the eye. For example when you watch a TV screen you'll notice that all the images are horizontal. You may also want to crop your images for a slide show to be shown on a TV screen. Older TVs usually have an aspect ratio (the ratio of width to height) of 4:3, whereas today's HD TVs and most computer monitors have an aspect ratio of 16:9. If you know what kind of TV or monitor (for example, HD) the slide show will be played on, then you can crop the images to match that ratio, allowing them to be shown full screen, with no borders. Most DSLRs have an aspect ratio of 3:2 while a lot of compact cameras have an aspect ratio of 4:3.

⬆ Including old or historic images in a slide presentation can give a clear picture of the before and after effect of the creation of a garden. To reproduce prints digitally, a flatbed scanner usually works best.

◐ Sometimes it's really useful to remind yourself where you have put things! A drainage pipe buried underground is a good example of what you might want to show in a presentation describing the infrastructure you implemented at the early stages of your garden design. This image has a bit of a magenta cast, which could be removed quite simply in a post-camera application, but Ian has succeeded here in making a drainpipe look aesthetically pleasing by roughly adhering to the compositional golden ratio.

◑ This photo offers another accurate reminder of all the work behind the building of the garden. Ian has used the scrolls of the turf to add interest to his picture and used good composition as a lesson in making a potentially dull subject interesting.

Consider how you can make interesting sequences. I've done this in my own garden with photographs of the same view taken through the seasons. If you are changing the layout of your garden you can illustrate the build up, starting with photographs of the design taking shape and the infrastructure being laid. You might even have old prints of the garden from a previous owner, which you could scan and then add to the sequence.

To convert prints into digital images, you'll probably want a flatbed scanner. Some scanners also have adapters for converting slides and negatives, but if you have lots of these, you should think about investing in a dedicated negative or transparency (slide) scanner as you'll get better results.

MAKING A PHOTO BOOK

There are many reasons why you may want to create a book of garden pictures: as a record of your plants from one year to the next, a gift for someone who has been helping you with the weeding over the months, a product to sell for charity at an open day, or just as a memento for yourself. Or, in Ian's case, as a record of thirty-five years of hard work creating his splendid garden.

Many of the same techniques that work for slide presentations can also work for books and anticipating the final design and layout before you take the photographs can help enormously.

It is best to capture your images at the largest size possible if you know in advance you will want to print them. Although dpi is unimportant when looking on a computer screen (which is constantly changing but rarely less than 72 ppi), to obtain a good quality when printing, make sure your images are big enough at 300 dpi to fill the space you want on the page. If you use an image shot as a panoramic on a smart phone or a tablet, the proportions will mean that the image may turn out very small indeed, in which case, if you really want to use it and show it off, then allocate it a double-page spread of its own.

Although your general photographic mission may be to fill your frame with the perfect composition, if you are intending to publish a book try to remember to pull back a little and leave more room than you might normally. That glorious view could make the lead image in the next chapter of your story so be sure to leave room for some text that you might want to add later when you design your book. Look through magazines or published coffee table books and you're sure to see double-page spreads with a headline or title written through the sky or the grass below.

MILL OF FYALL

Social Media from the Vale of Strathmore, Scotland

→ *Creating a visual diary for social media*
→ *Understanding histograms, contrast, and clarity*

⊙ My first impression of the garden. I deliberately photographed this shot against the light because the moment grabbed me. I needed to rush back to the car to grab my tripod so I'd be able to capture the scene while the striped shadows that the gate produced echoed the streams of light through the trees.

Scotland's ski slopes are just half an hour's drive from Mill of Fyall cottage, but that was hard to believe when I was there. It was September and the dahlias were a riot of colour, garlic was drying on the vegetable plot, and chickens were clucking happily in their pen.

Lisa and Gregg Hector created this cottage garden with great style, taking on the challenge of restoring a run-down property as their home and a workplace for Lisa, a textile artist and owner of Primrose Hill Studio. To me, the beauty of Lisa and Gregg's garden is the simplicity. I loved the picket fence with its wooden gate, and the family feel to the garden with lots of food to pick and eat, areas to sit and talk, plus plenty of amusement for their daughter, Stella.

Lisa's garden studio has become a venue for her wreath-making workshops and pop-up plant and craft sales. The raised vegetable beds, rustic wooden greenhouse, and sunny courtyard provide an endless source of photographs for her various social media posts. "I'm always looking to capture a beautiful moment in the garden, whether that be a butterfly on a flower or a view up through the veggie garden."

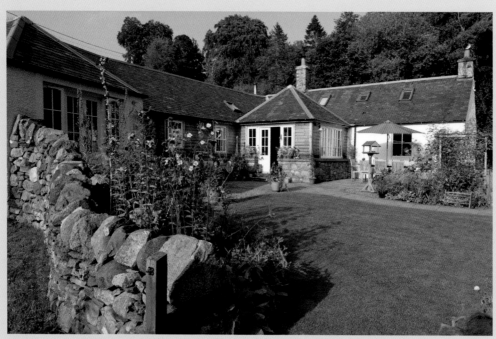

⊕ This overview photograph of the house and garden is more traditionally composed with the light falling over my shoulder. The lighting is not so bright that it has overexposed the white walls of the house, and the shadows aren't so deep that they hide information from the corners. However, I think the photograph has less drama than if I had photographed into the light.

⬆ As I moved around the garden I followed the light where it hit. I loved the old greenhouse that Lisa had fought hard to keep from being dismantled. Its vintage added character to the shot and the dust on its window panes diffused the light as it transmitted through the glass, adding a soft warm glow. No filter involved!

⬋ From time to time, Lisa opens the doors of her small workshop and sets up a table on the deck outside for pop-up plant and craft sales. I used my tripod when taking this photograph, looking out the door from the inside of Lisa's workshop. Very often when photographing through an open door, I'll take at least two exposures so that I'll have the option to blend them together as layers in a software application later. In this case, I took one shot correctly exposed for the table in the outside and one shot overexposed for the shadows. I merged the images later by layering in Adobe Photoshop in order to include some details of the wreath on the door while not overexposing the areas of deck that caught the light.

SHARING PHOTOS ON SOCIAL MEDIA

I found it fascinating that Lisa's grandfather, who introduced Lisa to gardening as a child, kept a detailed diary of his garden, and Lisa now keeps her own version of a visual diary on social media. For Lisa, recording her garden in pictures is a useful tool for memory jogging, perhaps as a reminder of the date she planted, but also where and how. She might also want to explain a practical tip to her followers. Captioning images is important too, as it was in the days of a photo album, but today it is even easier. All can be done in one application on the screen of a phone. As Lisa told me, "I do tend to capture 'moments' of life and post most days on Instagram, which become predominantly of the garden during the growing season."

When Instagram was launched, the image format was always square. The square format doesn't particularly lend itself to the nuances of the golden ratio—and personally I prefer the rectangular format—but the options have increased with Instagram upgrades, and rectangular formats, both landscape and portrait, are now used too.

The effects you can use with the application are fun and varied. You can choose from several named "filters" that combine a set of controls you'd find in other more conventional applications. Otherwise you can choose to add effects manually and play around with the results until you get the look you want. The vignette option accentuates your subject by adding a darker or lighter surround to the centre subject. The slider with the sun icon, known as the lux effect, allows you to quickly adjust the exposure and contrast together.

⟲ Practical shots, like Lisa's photo of a garlic harvest, illustrate a point clearly, which is essential for a good post on social media.

↥ I photographed the sweet pea arch looking one way using my DSLR. I applied no filters or effects and just used the natural light as it fell on the archway.

↧ Lisa photographed the sweet pea arch looking the other way with her smart phone. She used Instagram to add some extra interest and also to share it with her friends and followers. However, she was disappointed that the colours of the flowers didn't stand out as much as she wanted. Lisa told me that she "would love to make the archway of flowers more of a focal point and sharper," and she added an Instagram filter that increased the saturation of the blue sky and the greens of the foliage. I don't think the sharpness is an issue here, but lifting the shadows, which currently surround the flowers, and adding a little saturation to the reds would help them to pop out more brightly.

⬆ I found the photograph that Lisa took on a visit to the local park in February particularly enchanting. The gardeners there had the foresight and imagination to plant snowdrop bulbs in the shape of a heart. So simple. So pretty. It made a terrific picture for Lisa to shoot with her smart phone and post on social media. I made a mental note to plant snowdrop bulbs in our orchard later in the year—a super sight for Valentine's Day guests at my husband's B&B next February.

↗ This arrangement of freshly collected goose, duck, and hen eggs in a round basket fits perfectly in the centre of the square Instagram frame. Although Lisa broke the rule of thirds by having the main subject right in the middle of the frame, the image still has great impact. It also adds a personal memory to her visual diary.

⬆ Lisa's close-up of snakeshead fritillaries is beautifully composed and framed. Just one criticism: it might have been better to remove the plant label.

↗ With the caption "Spring has sprung at the back door!" Lisa posted her beautifully composed group photo on Instagram.

⬆ This picture succeeds because of the way Lisa styled the pots in the first place. The spread of the containers down the steps and the colours and textures of both flowers and foliage made it an easy scene to capture. I love the way Lisa let the red pelargonium trail off to the right and the evening light left a lacey shadow behind it. The composition fits well within the rules of the golden ratio—all I had to do was frame it.

This was a shady corner and the light was contrasty. I used the shadow slider on my post-camera software to reveal some of the details that would otherwise have been lost. I also used the highlight slider on the white paintwork of the door and window. If Lisa had captured the image on her smart phone she could have done the same in edit mode.

STILL LIFE: STYLING AND GROUPING

Lisa finds using her smart phone the most convenient way to capture images. She has developed an eye for picking out or creating styled still life images that work in the square format. In my experience, although the use of expensive camera equipment, sophisticated filters, or software applications can certainly enhance a photograph, nothing can substitute for an artistic eye.

Sometimes it's easy to overlook the obvious. When styling photographs for social media or otherwise, be sure that no glaring distractions such as plant labels are present in the photo. At home I prefer to remove plant labels and write down every new plant name in a book—sometimes I just staple in the plant label—and record the date and where I planted it. When I'm photographing other people's gardens and have to move a label out of a shot, I am always extremely anxious to return it immediately to the exact same spot as soon as I have taken my picture. It's so annoying to have photographers visit and muddle things up!

When grouping pots of plants together, balancing between colour and shape is all-important. Look at the balance of heights too, and if all your pots are a similar size and you don't have steps, then consider staging them using a small stepladder or even bricks.

HISTOGRAMS AND CONTRAST VERSUS CLARITY

A histogram is the graph that appears in the display on the back of your camera as well as in most software applications similar to Adobe Photoshop. Histograms represent the distribution of tones throughout your image. On the left side are the pure blacks and dark shadows. On the right are the pure whites

and your highlights. The values between them cover a range of mid-tones. The vertical axis shows how much of any tonal value, whether light or dark, appears in the image. The higher the peak, the higher the concentration of that particular value; the lower the peak, the lower the concentration. Therefore, if your peaks and troughs look like a view of the Himalayas, with tall mountains and deep valleys, you can be sure that your image will look very contrasty.

Contrast is an important element in any photograph. If faced with extremely challenging lighting conditions you will run the risk of the highlights becoming so white there will be no information at all in that part of the image—hence on the histogram the peak will be so high that it's off the scale or clipped. If the shadows are so dark that they become a black block then they will also become a peak and clipped off the histogram. It's all a question of taste and the choice is always up to you, but I prefer to photograph so there is almost always information to some degree in every part of my photographs.

So contrast is about intense dark and intense light areas—what about clarity? In many photo applications you will find a slider to control contrast and a separate one to control clarity. The clarity slider essentially adds more contrast to the mid-tones of your image, which makes them appear sharper as well as more highly contrasted. The contrast slider, on the other hand, increases the peaks and troughs of the histogram of your picture.

CAPTURING SEASONAL CHANGES

The weather often takes us by surprise. The great thing about using a smart phone to capture your images is that it is usually with you when you need it, in your back pocket or the inner lining of your coat in cold weather.

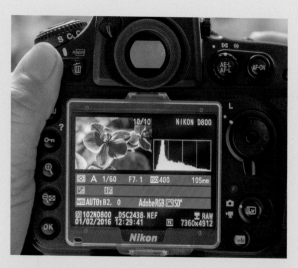

◐ The display on the back of your DSLR (and some compact cameras) will give you a lot of information about the contents of your image. The graph displayed here, called a histogram, shows the balance of pixels that are light or dark, with black pixels on the left and white on the right. With this guide it's easy to check that you have enough information in your picture—specifically that it is not over- or underexposed nor too contrasty. If the pattern spikes off the top of the graph (or "clips" it), you know there will be not enough information in that part of the tonal range.

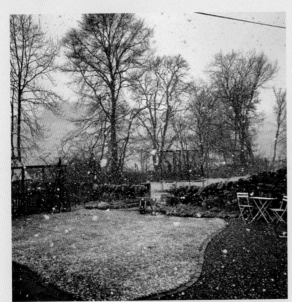

↩ It looks like Lisa was in the middle of some spring planting when snow unexpectedly started to fall and she snapped this photo with her smart phone. The scene was already subdued because of low lighting conditions. To enhance that, Lisa used the fade function to reduce the green in the majority of the picture even more. With an Instagram filter, Lisa exaggerated the red of the wheelbarrow and highlighted the little terracotta pots. The image now looks like a scene that could have been taken from her grandfather's photo album.

⬆ Lisa created this spring posy in her workshop to celebrate the start of spring, which in the Highlands of Scotland can vary greatly from year to year. This image acts as a super record of when her narcissus and tulips overlapped with the hazel catkins bursting into life. Lisa took the photograph from above to get a full effect and fill her frame; she then added a vintage film look by applying an Instagram filter.

➋ The perfect white spring blossoms on these boughs shine in the sun and it hardly matters that the tree is silhouetted against the light. The camera will have automatically exposed for the bigger area of sky and blossoms, leaving the stems in shadow. Lisa used the shadow and highlight sliders to add a little detail and the vignette function to emphasize the glorious sunlight through the branches.

FARRS

John and Jennie Makepeace's Crafted and Colourful English Garden

→ *Using colour and light to reveal a garden's character*
→ *Getting detail in shadows*

⊙ A giant topiary mix of yew and box winds its way through John and Jennie Makepeace's fascinating garden. The hedges were there before John and Jennie took ownership and were once shaped as a huge steam train. They have since been allowed to grow exponentially into voluptuous sculpted abstract forms.

Anyone who knows the exquisitely organic furniture designs of John Makepeace would expect nothing ordinary from the garden that he shares with his wife, Jennie. It is divided into two sides. John's part reflects his flare for contemporary design and includes a turret-shaped garden room surrounded by a richly textured tapestry of ornamental grasses. A simple wooden bridge with a supporting beam painted in brilliant pink leads to this retreat. Jennie's part of the garden is a more traditional country haven. In season it's a cornucopia of flowers, fruit, and vegetables. All the same, her area is hardly short of stylish structures. A studio built of strawbales is enhanced with carefully crafted rustic furniture for Jennie to relax in between busy hours in the garden. A riven oak–beamed fruit cage keeps away the avian berry burglars while the greenhouse in the centre of her colourful garden has served as a sanctuary for homeless hedgehogs.

John mostly works from home and takes the opportunity on bright days for short breaks to walk around the garden with his camera—a snazzy but simple compact digital camera with a built-in zoom lens. He has owned it a few years and considers it an old, reliable friend. It is also small enough to keep in his pocket for those daily breaks. As he told me, "It surprises me how often I see a view I had not been aware of before."

John and Jennie's garden is at its best in late summer and can be visited under the National Gardens Scheme, which supports many charities by donating the fees paid to enter gardens all over England and Wales. This motivates John to capture their garden in pictures on a regular basis to entice more visitors to their open days. Visitors especially enjoy seeing not only a contemporary garden but also a modern interior in a historic house.

GETTING UP HIGH: OVERVIEWS

Getting a high viewpoint is not only interesting from a compositional angle: it's really important if you are trying to lure the public into your garden space for a charity fundraising event. When John and Jennie open their garden each year, the turnout is always good. Of course, this is partly because of the intrigue to see the garden of a celebrity furniture designer. But it's also because the couple has promoted the garden extremely well and taken good photographs that show the overviews and not just details.

You only have to talk to a district organizer of this scheme—or a similar one anywhere—and they will tell you that they tear their hair out requesting garden owners not to photograph plant close-ups for this purpose (as much fun as it is), but to photograph views to give potential visitors a real idea as to why they should make the journey.

Getting an overall view of your garden can be important for other reasons as well. You may want to log changes for your garden design, noting seasonal variations. An overview is also essential to create a framework in which to place the planting details later as you make further revisions.

⬆ Think about why visitors want to visit you. There is usually a degree of nosiness. Occasionally John and Jennie open some rooms in the house as well as the garden as visitors are always interested to see how the garden looks from inside while glimpsing some of the interior furnishings.

John joked with me that I must keep a cherry picker in my camera bag as an essential piece of camera kit. On many occasions I wish that were true, but even I can't always hire a cherry picker for every job. However, I do always bring a ladder on every photo shoot to gain that extra height. Finding an upstairs window that looks out over the garden and provides a unique viewpoint is another option for capturing the overview.

⬆ From an upstairs bedroom window, John photographed the whole garden for their open day. The height was essential, as 10-foot walls and those towering hedges surround the garden. His shot revealed the merging of the two gardens and the sweeps and curves of the paths that link them together.

A TALE OF TWO GARDENS IN ONE

When photographing any garden, but especially a highly unique one like John and Jennie's, revealing character and telling the story is an important and fun part of the process. It's always intriguing to know a little backstory about the garden owners—it helps tell the story. For the garden of a distinguished woodworker I thought it would also be interesting to show the tools of his trade. It was also important to include a few images of the finished works in the context of the garden to complete the tale.

When discussing Jennie's area of the garden, John told me that he found it much more difficult to photograph than the grass garden, perhaps in part because of the sheer riot of colour that gives the space such a wow factor when you turn the corner of the path and enter it for the first time. Your eyes have just been acclimatized to the greens of the topiary and the golds of the grasses in John's portion. Jennie's is not a garden to photograph in the harsh midday summer sun.

Luckily, I visited in the early morning and found the muted pinks of Jennie's 'Broughton Star' clematis perfectly complemented the pale green paintwork of her summerhouse, coming as these colours do from opposite sides of the artist's colour wheel. The tones of colour were gentle and the early summer May sunlight dappled and kind through the scattered clouds.

⬆ A bit of insight into the background story of the garden can add extra interest. This photograph offers a peek at once-magnificent trees, now planked and seasoning in John's open-sided barn.

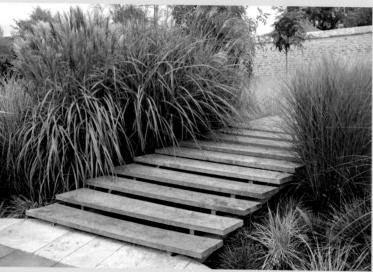

⬆ ⬈ Visitors to the garden will be intrigued to see John's craft outside in the context of his garden.

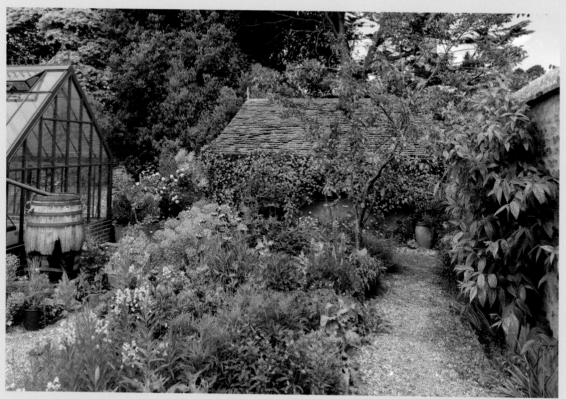

⬆ Jennie's garden plot is more traditionally designed and displays the feminine side of the gardening partnership, in my opinion the perfect English country garden to visit on a summer's day.

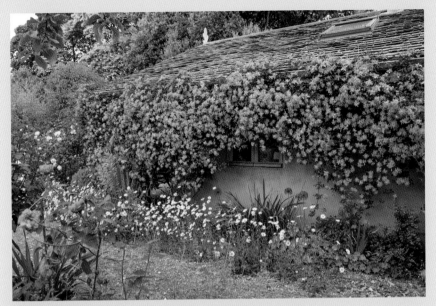

↑ ↙ 'Broughton Star' clematis in Jennie's garden.

COLOUR IN THE GARDEN

John may work predominantly with wood as a raw material, but you don't have to look far through his back catalogue to find many vivid colours in his diversely commissioned pieces.

In his own garden, a brilliant pink highlights the underside of the bridge to his retreat. And the wooden door at the back of his stone building is painted in an extraordinarily intense shade of blue that is strangely close to Majorelle Blue—a colour with an interesting history. In the 1920s the French artist Jacques Majorelle noticed the colour in Moroccan tiles around many of the domestic homes and traditional buildings in Marrakesh and used it on the walls and water features in his masterpiece garden known as La Majorelle in the capital city. He trademarked the colour and the

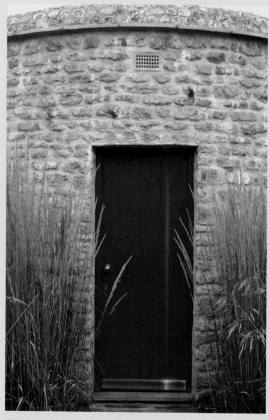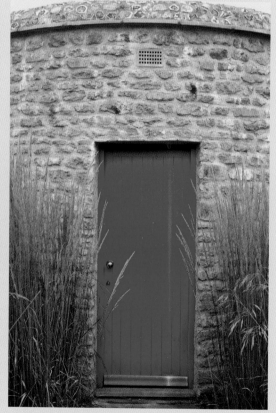

⬆ I changed the hue of John's door from blue to green.

garden became famous when the fashion designer Yves Saint Laurent purchased it later. When I was researching the history of this colour I noticed that Jacques Majorelle's father, Louis, was an esteemed cabinet maker himself—a fact not lost on John who was, as it turned out, an ardent admirer of his work.

John and Jennie's garden, with its range of vibrant colours and subdued tones, illustrates some basic colour concepts that can sometimes be confused: hue, saturation, and luminance.

HUE Is hue really only another word for colour? Not quite. Think of the colours in the rainbow, a total of seven. Red, yellow, and blue are the unique hues; then there are the secondary green, orange, and violet, and tertiary indigo. In painting terms, a hue refers to a pure colour, one without any black or white pigment added. Usually,

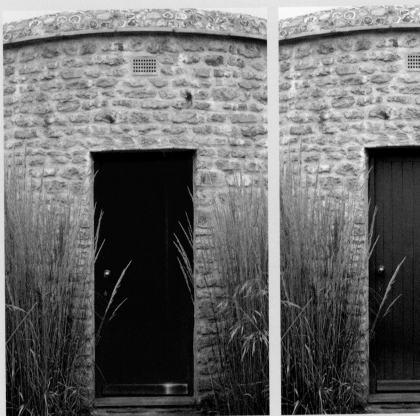

◑ It all depends what mood you want to portray with your image. Here the blue colour of John's door is cheerful and highly saturated.

◐ I used the saturation slider to desaturate the blue a little and subdue the mood.

colours with the same hue are distinguished by referring to their lightness and or colourfulness, such as with light red, pastel yellow, or vivid blue. To change the hue of John's door, you'd have to change it completely to say, red, green, or yellow.

SATURATION Also known as chroma, saturation refers to the intensity of the hue or, in other words, the purity of the colour. Using one wavelength at a high intensity produces a highly saturated colour. If you decrease the intensity, the saturation will diminish. Pictures generally look livelier with increased saturation but take care not to oversaturate your images, especially if you want to print them. Don't forget, printing inks may not offer the same intensity of colour as you see on your monitor screen.

The vibrance slider on your application will also increase or decrease saturation and is particularly useful in preventing skin tones from becoming oversaturated. Therefore, if you want to increase the vibrance of a scene and yet not alter the skin tones of the people included, this is a good tool to use.

LUMINANCE Referring to the brightness level of the hue (that is, how light or dark), luminance is generally controlled by exposure. A picture of John's blue door when underexposed will appear darker than if the same door is overexposed. Similarly, when the bridge to his retreat is photographed in bright winter light, the pink appears much lighter than in the shade later in the year.

SEASONAL LIGHT, CLOUDS, AND GRASSES

Depending on which part of the world you live in, you will notice that at different times of year light appears to give a different effect. In some areas it is subtler than others. In the United Kingdom and northern parts of the United States, for example, winter light can provide clear and sharp light that exaggerates shadows and amplifies colour.

Clouds can often provide the natural diffuser you need to avoid overexposing areas of your images, especially when photographing grasses. A good but unscientific trick that I often use to remind myself that a scene is too bright and to wait for a cloud is simply to squint both eyes closed and see if the resulting image is so contrasty that it's either not worth taking or it's worth waiting for a cloud to arrive to help.

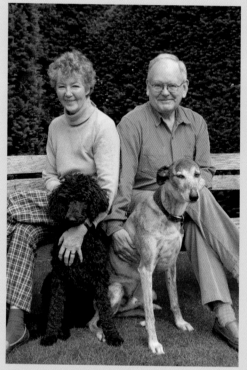

⬆ I added some vibrance using the slider, thereby increasing the saturation to the greens and blues and the orange of John's socks, but using this tool hardly touches the skin tones of their faces.

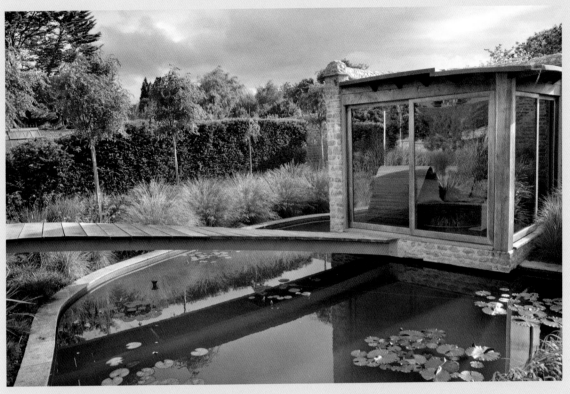

⬆ ⬋ Luminance is all about the brightness (seen as light or darkness) of the hue. The pink colour of John's bridge appeared darker when photographed in shade than when it was photographed in bright winter light.

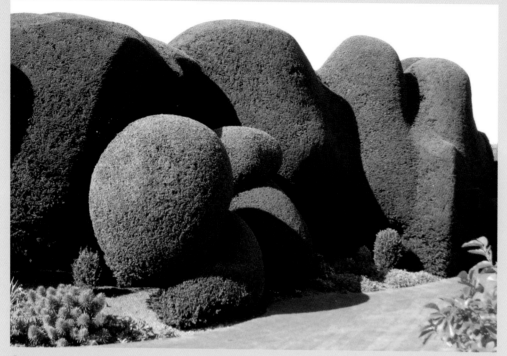

⬆ John's photograph of the topiary hedging is accentuated by strong contrasting light, giving clear dark shadows.

⬆ The occasional passing cloud in summer naturally gives the image more colour saturation.

⊕ I find cloudy days best when I am photo-graphing grasses because the clouds provide the necessary diffusion. There was just enough light to add a glint or shine to the texture of the bowed blades.

⊙ John's image of the grasses takes advantage of a sunny day with plenty of clouds. The late summer seed heads of his ornamental grasses are gleaming and show a wide range of beautiful textures.

GETTING DETAIL IN SHADOWS

When I photographed John's grass garden, the winter light was strong and gave real drama to the scene. However, it also provided deep shadow where I lost some of the detail, especially in the dark sword-like fronds of *Phormium*. Taking a number of differing exposures and blending them later using a software application will only work if the layers match or register. If there is the slightest breeze and the stems of fine grasses move at all, this is not possible. So now is the time to use the shadow tool and remove any shadow you can within reason. Take care not to overdo it. I always strive to make my pictures look as natural as possible by allowing some shadow to remain.

⬆ I loved these pleached trees holding hands like a row of paper chain people. However, by the time I got to photograph this scene my time in this special garden was running out so I had no option but to photograph them against some quite strong midday light.

I really wanted to get some details in the tiny dark foliage. In this instance there was no breeze and the trees were stable. So, with my camera set on my tripod I was able to take two exposures from exactly the same spot: one of the exact average meter reading and one a stop overexposed. I used the spot meter function on my camera for this situation so I could get a precise measurement aiming the camera at the foliage. Later when working in a post-camera application on my computer, I blended these two images together as layers, giving me the result shown here.

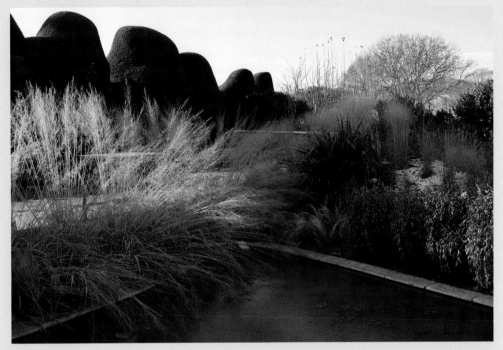

⬆ Getting some details in the shadows is sometimes only possible after the shoot in a post-camera application. Too much breeze would not allow me to bracket my exposures and combine later as they would not have registered, and so the shadow tool is my last resort.

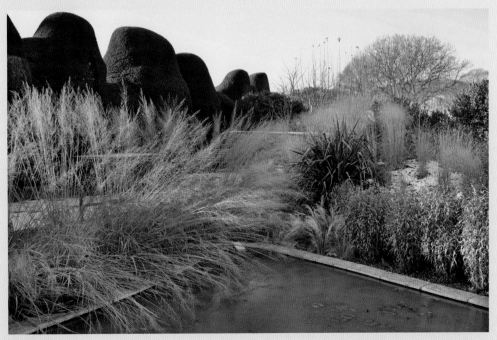

⬆ I used the shadow slider in Photoshop to remove some of the shadows and increase the level of detail in the grasses.

NANCYLAND

Curating Creativity in Oregon, USA

→ *Capturing the style of a garden*
→ *Playing with depth of field*

This glimpse into Nancy Goldman's back garden really captures the mood. The mix of recycled and salvaged items nestled into the jungle of plants gives a feel of relaxed antiquity while providing practical support for the plants and also seating for visitors. I used an aperture of just f/6.3 for a soft, gentle effect.

Nancy Goldman's garden isn't difficult to find, spilling out onto the sidewalk in a glorious explosion of flowers and foliage that stops passers-by in their tracks. Her house, on the other hand, is practically hidden behind all that greenery. It was hard to catch more than a glimpse of the red bricks from the street.

Walking up the garden path I was enchanted by the whimsical details and the reclaimed objects acting as containers for many exotic plants. It isn't every day that you find stiletto shoes filled with succulents or sundae dishes transformed into a rainbow-coloured fountain, yet here they were, looking perfectly at home in this lively setting. The garden is an inspiration to visit and there are so many photo opportunities within its boundaries.

It is a garden that perfectly expresses its owner's sense of fun. Nancy is outgoing and dynamic and she loves sharing her creative ideas with others. Her goal is to provide "a welcoming and enjoyable experience" to her many garden visitors. This is also a garden that never stands still, so photographing it is a way of capturing the moment and documenting the progress. These photographs help Nancy to promote her garden tours and to support local fundraisers where a tour of Nancyland with tea in the garden is a popular auction prize. This is all done by word of mouth and through Nancy's busy social life—not social media. Nancy does not have a blog or a website.

THE PANORAMIC VIEW

When photographing a garden like Nancy's with so many vibrant details, hidden corners, and layers of planting, I soon recognized that the challenge would not be what to photograph, but how to find the single image that would perfectly encapsulate the spirit of this unique garden.

Nancy's house is only one storey high, with no upstairs window or flat roof overlooking the garden, so getting a garden overview from above was impossible. Even experimenting with ladders didn't work. Short of renting a helicopter, I thought a panoramic image might help capture the sense of place at Nancyland.

For a couple of decades I have enjoyed using a Fuji GX 67, a rather substantial film camera (by modern-day standards at least) that uses 120 roll film. The finished film gives superb quality results, each frame being such a big file size when scanned that it would probably enlarge to cover the side of a bus. It has become one of my photographic trademarks over the years.

Today there are many other ways to capture this letterbox format of the panoramic. Nancy uses a compact camera for some of her garden pictures and also a smart phone. Some compact cameras have a built-in mask, which simply crops out part of the top and bottom of the image to leave a panoramic shape in the middle. This is all very well but you also lose about two-thirds of the image file size this way.

With smart phones, you can create an effective panoramic picture (albeit with a rather distorted view) by scanning an image vertically from one side to the other. I always do a practice run first when using this feature, as it can be a bit tricky to hold and scan without wobbling. Set the height so you include all the details that you want and high enough so you don't include your shadow. Then smoothly and slowly move

➲ Like her garden, Nancy is a delight to photograph as she smiles easily and radiates fun, and so it seemed obvious to try to capture her personality in a portrait. It was a bright day on this visit so I sat Nancy in a relaxed garden chair looking towards me with her back to the sun. Why put her face in the shade? The sun was way too bright and would have been harsh and not flattering on her face. I used the gold-threaded side of my reflector to bounce light gently back at Nancy's face. A white piece of board would also have helped remove any unwanted shadows but would not have given the gentle golden glow.

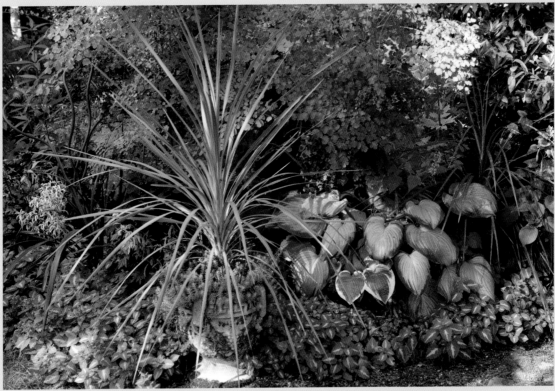

➲ Nancy's garden is rich in texture too. Although this landscape photograph consists almost entirely of greens, the variety and pattern of the different textures makes the image work. Gentle low light helps pick out the edges of the glossy leaves but most of the shapes are defined better in the shade and the tones of green colours are more intense.

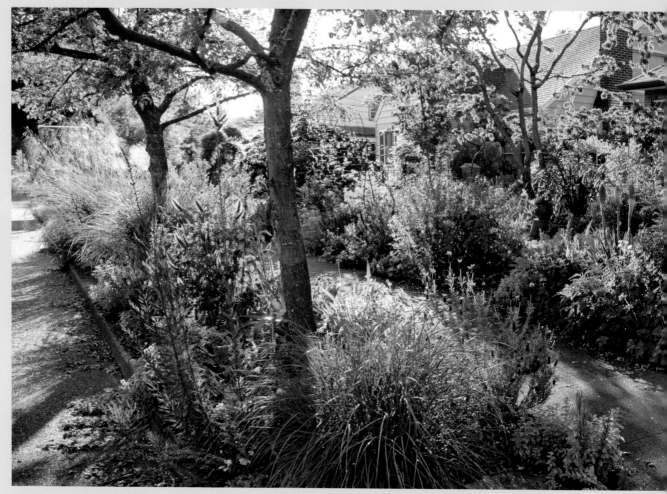

⊕ A letterbox-shaped panoramic image can help give the feeling of a sense of place. The hellstrip (the strip between the sidewalk and the street) leads into Nancy's garden. I used my panoramic film camera to capture the wide view without distorting the perspective.

the camera from left to right while keeping the pointer on the guideline. It's true you can always edit afterwards but don't forget that cropping also cuts the file size so ultimately you lose image quality. As with all photography I prefer getting it right in the camera first.

The other alternative is photo stitching, a technique that combines multiple images with overlapping fields of view to produce a panoramic view. Many computer software applications will help you do this, but to start with you need a series of individual images that overlap and are taken with identical exposures. You can then achieve seamless results.

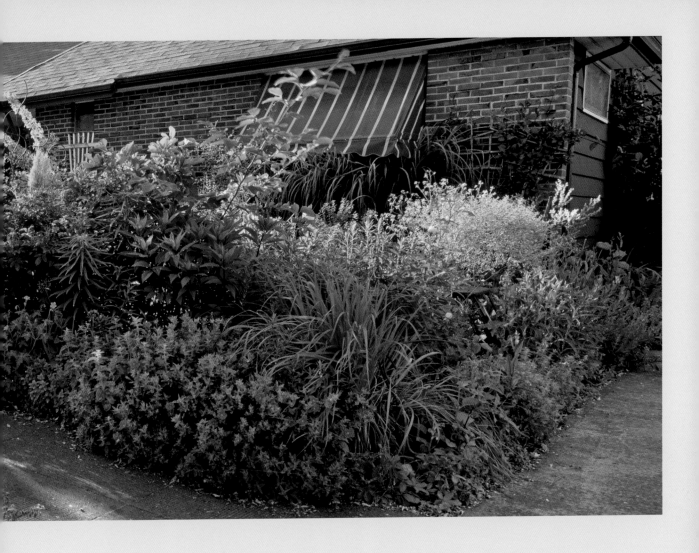

When capturing your images to stitch together, first of all be sure to stand in one spot and just rotate your body, keeping your camera level (I'd use a tripod). Use one focal length only (be careful if using a zoom lens) and set the focus and exposure manually if you can—using the auto setting may change the exposure or focus point during the capture of several images. Adobe Photoshop (adobe.com) recommend that you capture your images in portrait orientation and overlap each image by 25 to 40 percent. When you have downloaded the images, follow your software instructions to merge the images into one final image. You may need to make a final crop to tidy up the edges.

CAPTURING THE DETAILS

The many little areas of Nancy's garden are connected with colourful jungle-like paths and Nancy's imaginative styling is inspiring. As I walked among those paths, I took photographs of the unique style and details of Nancyland. Her talent at finding and using unwanted treasures from car boot or yard sales was on display everywhere I looked. In a garden dense with objects and plants, it's important to walk slowly and savour the whimsical details and surprises around every corner.

❶ The bright colours of the children's lettering—spelling out Latin words roughly translated as "My Kick-Ass Garden"—are connected to the colourful plants in the vase below. Nancy styled this corner and framed it with ferns and plenty of green foliage. I used the silver-threaded side of my reflector to bounce some light into the shadows near the bottom of the scene.

❷ Natural light and shadows falling across the fence accentuate this little group of relief art-works. The long gentle shadows help remind me that I took this picture in the early morning.

⟳ Nancy numbered a set of terra-cotta pots and placed them on a shelf outside her front path to identify her house number for visitors. This straightforward photograph of a great idea benefited from a bit of patience when I waited for the light to fall gently so as not to put the numbers in shade or overexpose the highlights, which give the pots their sense of form.

⬆ This pretty ornate fan attached to the fence needs nothing else to complicate the image. I diffused the light with my white diffuser to eliminate glare, just allowing a slight sheen to pick up the details of the metal work.

⟳ I love the rainbow-coloured water feature that Nancy made from discarded sundae dishes. With my DSLR camera in my hand I moved around the feature first and looked hard to find the best angle so that the colourful flowers and their stems framed and enhanced it. Then I set up my tripod and used an aperture of just f/6.3 to capture this image, blurring the colourful flowers behind. I let one blade of grass overlap in the front to give a sense of deepened, layered perspective. Photographing glass is rarely as easy as it looks. Beware of unwanted reflections—especially your own.

⬆ Unusual containers come in all shapes and sizes—even stilettos—and make for an interesting photograph. I used a mid-range depth of field for the photograph. An aperture of f/7.1 ensured that the details of the shoes and succulents were sharp but the background was just softly focused enough so as not to distract from the main image.

↻ Nancy had this stiletto especially made in steel. I photographed it using a shallow depth of field to blur the colourful planting in the background and get maximum impact. I used an aperture of just f/5 for this picture and focused on the intricate detail of the front of the slipper.

DEPTH OF FIELD

When I was first studying photography, I found depth of field to be the most difficult concept to completely understand, so it appears in several scenarios throughout this book. In this case, I'm looking at a few practical ways that depth of field crops up and how understanding it can help make better pictures.

If your camera has a depth of field preview button, I highly recommend that you use it. I use this button on my camera as frequently as my shutter release button. In fact, I probably use the preview button more, as I often check how my image will look several times before finally clicking that shutter button. Depth of field preview will not only give you a sneak peek of the area your focus will cover, but because it does that, it will also reveal unwanted items when it shows you how the real result will look. When you are not using a depth of field preview button, the viewfinder usually shows you how the picture would look if the shot were taken with the aperture fully open (in other words, with a shallow depth of field) so that any area not specifically focused upon will look slightly blurry. This can be misleading and I believe is at the core of many disappointing images.

⬆ It happens to us all: we think we've taken the perfect shot, it even looks great in the display panel of the camera—but then we get it on the screen back at base and there's that cat walking across the background, a label sticking out, or, in this case, a hosepipe in the yard that went unnoticed. Nancy realized what she'd done: "Yes, the purple hose is in the picture," she told me. "But at least it's purple!" True! If Nancy had been using a DSLR with a depth of field preview button, she would have likely noticed the hosepipe when taking the image.

◔ In her garden Nancy has the most beautiful rusted metal screen with a fern cut out. I especially like how she thoughtfully lined up the negative space of the fern with the tree behind, which gave it colour and texture instead of just the whiteness of the sky. I think that she did a pretty good job, considering she was using her smart phone.

Nancy asked me for ideas on how to photograph the screen without the neighbour's yard in the frame. In this case she needed enough depth of field to keep the screen in sharp focus, especially where the edges give the shape, but not so much depth of field as to keep the view in the distance in focus. Ideally the image would concentrate the eye on the subject and the neighbour's garden would fade into insignificance.

In some cases touching the screen of your smart phone guides the camera's focus to where you want the image to be sharp. To take your images to the next level, use the manual focus (if your smart phone has such a thing) and focus lock on the area you want sharp. The secret to getting your main subject sharp and the background out of focus is to understand how to manage the distance from the lens to the subject. The closer your camera lens gets to the object you're shooting, the more out of focus or blurry your background will become.

◑ For this photograph Nancy used her smart phone, which automatically selected a fairly wide open aperture of f/2.4. This resulted in an extremely shallow depth of field—perhaps in this case not ideal for such a detail-filled picture. The camera probably selected this because the light level was low and it needed to compensate. This was a difficult situation to overcome without the controls of a more sophisticated camera. The only alternative would have been to wait until more diffused light was available.

SHARPNESS CLOSE-UP

Close-focus photography is probably the most popular area of garden photography. You can achieve very successful photographs with a compact camera or even a smart phone. And it's fun!

Most compact cameras have macro or close-up settings, which are often identified with a flower-shaped icon. This setting changes how autofocus works as the camera can focus on subjects closer than 3 feet instead of 3 feet away and further.

How close your camera can get to the subject and still achieve sharp focus varies with each camera model. It's worth checking the camera manual or looking online for the specifications if you're using a phone or tablet. Then experiment by moving your lens nearer to and farther from the subject and see what works well for the size of the subject. In the case of a spider web you might want to be close to it, but the subject itself covers quite a wide area too—so in fact it doesn't qualify as a macro subject as it would if you were photographing the spider itself.

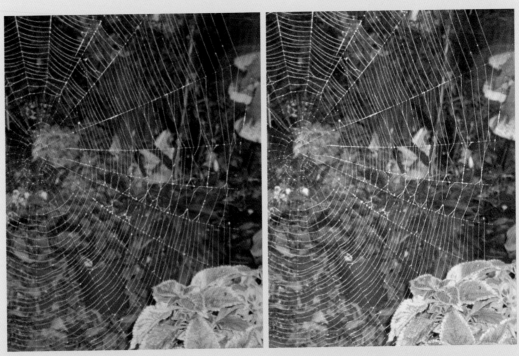

↥ "All about the details," is how Nancy described this image that she took with her compact camera. We both appreciated the excellent placement of the web in the frame, the cheerfully vibrant colours in the background, and the darkness of the picture that allows the spider web to show by contrast. If anything, I would suggest adding even more contrast and lifting the highlights, which in this case are the gossamer threads themselves. I would also check the focus. With such a delicate scene it's worth taking the trouble to set your camera up on a tripod. The camera has a much better chance of focusing correctly when it is steady.

❷ I increased the exposure on this version and also used the clarity slider to add contrast to the mid-tones only, thus improving the appearance of sharpness.

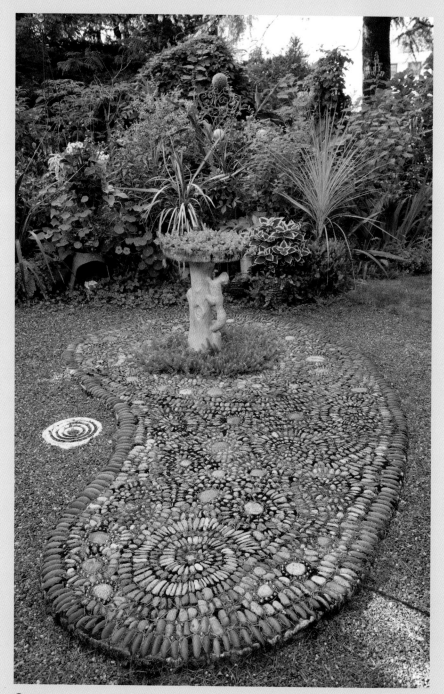

⬆ Jeff Bale, a local mosaic artist and landscape architect, designed and installed the beautiful pebble mosaic in Nancy's garden. Jeff used a tiny piece of fabric with a paisley design as inspiration for this feature, which measures about 6 feet long and 3 to 4 feet wide. The mosaic is set in a gravel area in her back garden and you have to walk by or through it to reach the lower garden. The mosaic looks good all year round, but Nancy especially loves the marbles as they sparkle in the sunlight.

BRIGHTNESS VERSUS CONTRAST

To lift the light levels in a photograph, you have a few options using either a post-camera application or the sliders in your smart phone. The brightness slider simply brightens the entire image from the shadows to the highlights equally, including the mid-tones, while the contrast slider increases the contrast of the highlights and shadows.

Here let's look at how the brightness and contrast sliders compare when they are applied to the same slightly dull image of Nancy's mosaic.

⬆ Nancy photographed a detail of the mosaic using her smart phone. Although the mosaic is delightful, the picture is a little dull and perhaps doesn't show off the artwork to the best effect.

⬆ To this version, I applied the brightness slider, which simply brightens the entire image from the shadows to the highlights equally, including the mid-tones.

⬆ I also applied the contrast control to this image to accentuate the highlights and shadows and give the stones a bit more sparkle.

ARD DARAICH

Sketching in the Scottish Highlands

→ *Telling the story of a garden and its gardeners*
→ *Using the garden as inspiration for art*

◐ I knew that their house sat on a steep site, so I was intrigued to find out what kind of garden the Maclarens had carved out of this rugged terrain. I discovered that they had approached the sheer rock face rising directly behind their house as a living canvas, working with the contours of the landscape and celebrating the textures of bark, stone, and moss to create an enhanced version of nature. This was wilderness improved but untamed.

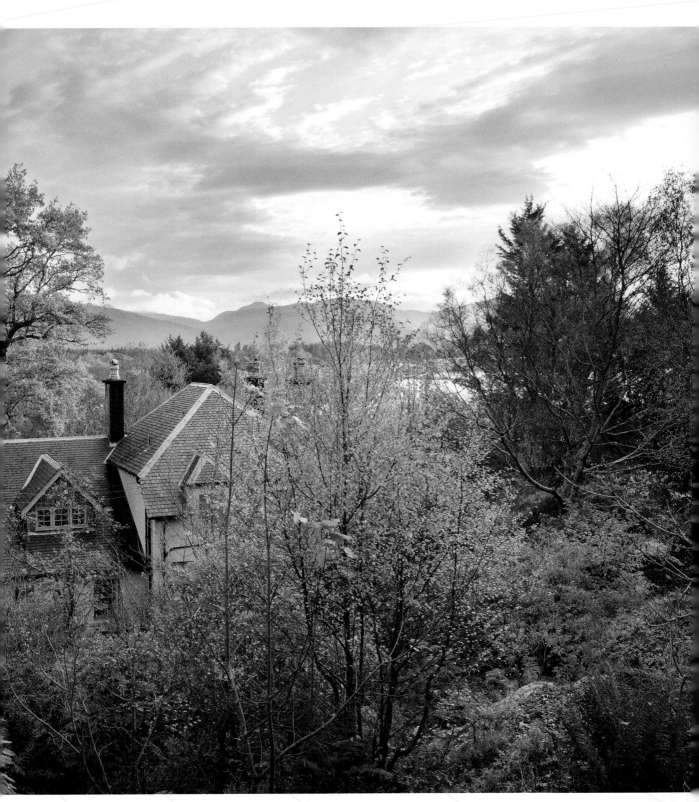

It is only a short ferry journey across Loch Linnhe to the Ardnamurchan peninsula but otters fish these waters and sea eagles soar above them, so by the time you reach the shore the sense of remoteness is profound. Ard Daraich was once the holiday residence of celebrity florist Constance Spry; now it is home to Norrie Maclaren—a television producer, rhododendron collector, and convivial B&B host—and his wife, Anna, an accomplished artist and keen gardener.

Photographing this garden was a joy, as I have a lifelong love of natural history and I could share Anna's appreciation for the details, which she records with her camera to use as inspiration for her art. Equally I could understand what drives Norrie to take close-ups of his rhododendrons, some of which are quite rare. I was also drawn to turn outwards from the garden to capture the vast landscape and the views across the loch where the water shimmered in the light.

Norrie and Anna open their garden each year to fundraise for charities organized by Scotland's Gardens and are sometimes asked to submit photos of the house and garden for promotional purposes. Anna explained that the organizers often comment that the couple's photos tend to be close-up plant portraits rather than bigger views of the garden, which "tells me that both Norrie and I are more interested in detail and indicates that we need to widen our lens and capture more of the atmosphere of place."

SHOOTING PLANTS

An avid collector of species rhododendrons, Norrie has amassed quite an interesting selection over the years, some of which are now rare in cultivation and have even been lost in their country of origin. In 2013 the Rhododendron Species Conservation Group logged the position of as many plants as they could in the Maclarens' garden with sat-nav (satellite navigation) or GPS (Global Positioning System). When photographing species in the wild, it is now also possible to note their location through enabling a GPS feature on some digital devices. Maintaining the collection and documenting the species on a regular basis will be of significant botanical value in the future.

⬆ I climbed to Anna and Norrie's viewpoint for this photograph. The view was stunning. I set my camera on the tripod and looked across the water through the trees. Wanting to leave the trees in silhouette, I pointed my camera to the light on the water and allowed the exposure and focus to read from that area of highlight. This left the dark areas really dark. I also wanted to be sure that the focus was sharp on the water throughout the ripples. The image is virtually monochrome with just a little warmth showing from the last of the sun's rays.

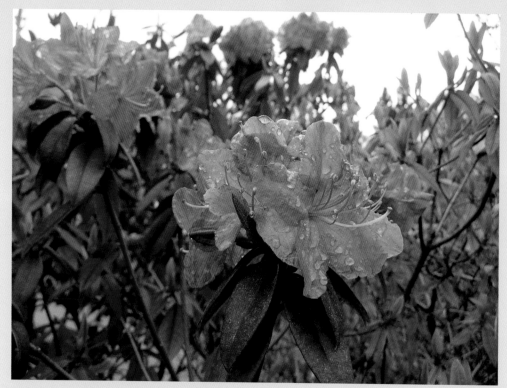

⬆ With his Panasonic Lumix digital camera, Norrie uses the same angle of view (50mm) with his zoom lens for every plant portrait. Setting himself some stylistic parameters before starting to photograph the rhododendron flowers, Norrie notes that he "stayed on the same focal length and moved about the garden, sometimes waiting for the light to be in a certain position in the sky." For the purpose of horticultural records, using the same focal length at all times would give a standard view, whereas if Norrie changed the focal length and on occasion photographed a flower, for example, in close-up using a wider angle, the flower may appear larger than in reality.

⬅ Though Norrie mostly concentrates on photographing flowers, he sometimes focuses on the leaves "if they have spectacular indumentums," which are the brown fur-like texture under the leaves. As Norrie told me, "The narrative is purely floral, and the shapes and colours will take the viewer around our hill garden. There is something very sexual about the pictures." With invasive rhododendrons subject to bad press in Britain recently, his photographs are truly "a celebration of a species." Like Norrie, I am constantly impressed by this hidden detail so I captured the moment of turning over the rhododendron leaf to expose the indumentum.

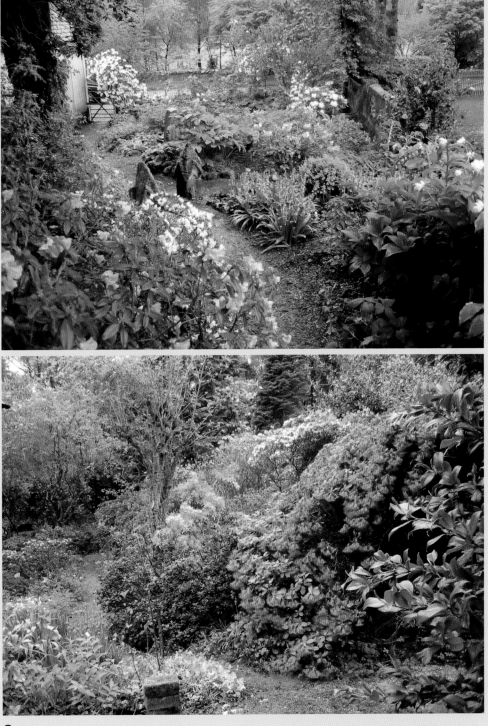

⬆ Anna's spring photographs capture the colourful floral stage of a rhododendron garden—as Norrie put it, "the moment when out of a 'green bush' a tremendous variety of colours appear."

TELLING A STORY WITH PEOPLE AND MOVEMENT

Having walked around the garden at length, I realized the various paths all had a story to tell. Instead of a single path to the viewpoint, a series of routes wind up to the highest ledge. There, Norrie and Anna have built a seat for enjoying those rare moments of quiet in the wonderful environment that they live in with a cup of coffee on a cold day or a glass of wine on a summer evening. I wanted to show the sloping path but it looked empty as a picture so I asked Norrie and Anna to walk along so I could photograph them in motion and also give a sense of scale.

↻ This would have been a nice enough photograph with just the scenery, but the addition of the Maclarens enjoying the walk through the hillside garden helps tell the story. Had Norrie wished to take this shot himself, he could have set his camera up on a tripod, aimed it at the path, and triggered his self-timer. In this case he would have probably asked Anna to walk along the track for him to test out the timing and get the shutter to release when they were both in the correct position.

⤶ Anna was gathering hydrangeas and autumn foliage to make an arrangement for the house and I was struck by the combination of rich muted colours that she was both wearing and carrying. I used my camera to take an average exposure reading of the scene. By angling the warmer gold side of my reflector towards the light, I was able to fill in the shadows and also add a bit of extra sparkle to her eyes.

❶ The story is often told better with a little movement. Posed and motionless, the simple task of emptying a wheelbarrow of leaves was recorded but in a relatively uninteresting manner. I shot the image at ⅟₆₀ of a second to freeze the movement.

❷ Asking the couple to throw their weight behind the task and "heave ho" made them laugh. With my camera securely on a tripod and using a slower shutter speed (⅟₃₀ of a second), I caught the movement of the leaves tipping into the compost heap.

THE GARDEN AS INSPIRATION

When Anna produces artwork it's always from life, but she uses her camera to make a visual aide-mémoire. Over the course of her career, Anna has experimented with SLR film cameras as well as newer compact cameras "to frame and explore subject matter." With limited photography skills, she often felt frustrated with the expensive task of developing film in exchange for only a few useable images. It wasn't until Anna went on a photography workshop in England that she gained more success in taking photos. At that time she was working as a gardener and designer and needed to improve her skills at recording her work for promotional purposes. Now she constantly uses a compact digital camera as her sketchbook.

Anna also recently started using Instagram on her smart phone to promote both her career as a painter and, under another name and separate account, Ard Daraich as a destination. She now has quite a distinguished following. Another major task for Anna is to provide fresh images every season for the website they have developed and maintain for their B&B.

↻ Anna never paints from photographs but uses her camera to sketch out ideas that have inspired her from the nature that exists all around in her garden. She uses these *aides-mémoire* to produce a variety of artworks. She has shown some of her paintings in exhibitions; she has also produced art books of images joined together in a folding format, one of which I am a proud owner.

⊕ The garden throughout the year is an inspiration for Anna's artistic colour palette. Anna appreciates winter—a change from spring's "strong colours and exuberant plant forms reminiscent of Jurassic gardening"—for its reduced colour palette and "miniature world of mosses and lichen contrasting the skeletal form of bare branches and bark."

⊕ Anna doesn't always dwell on muted colours. Her artistic eye has captured a group of colours that in the wrong hands might have jarred. In this case they have provided yet more inspiration for her artwork.

⬆ Anna's sister, Jane, another talented artist, made this stone for Anna. Jane collects her stones from different places around Scotland, and they range in colour from light to dark grey to pinkish-purple and yellowy sandstone. I photographed this one, nestled in the moss, in the shade to allow the details to be clear. I used a diffuser overhead just enough to keep the engraved name readable, but I let the sun shine through on the nearby glossy holly leaves. I love the juxtaposition of the two textures: smooth and hard grey stone with soft and verdant moss.

MOSSES AND OTHER DETAILED TEXTURES

I've enjoyed the subject of natural history since childhood and spending time with Anna exploring the minute details in the understorey of her shared woodland reminded me of an art competition I entered as a child when I decided to draw a fir cone. I laboured over a pen and ink drawing, increasingly fascinated by the amount of detail in this tiny, otherwise rather overlooked, natural object.

I remember the pure joy of exploring the minute intricacies of this wonder of the natural world and drawing exploded details, with my nib, of that tiny, somewhat insignificant, cone. Today I'm more likely to use a camera and macro lens, but it was wonderful to share some moments of appreciation of this other world with Anna.

↩ Anna loves the moss on these stone finials. I photographed the detail from a distance, manually focusing my 105mm Micro Nikkor lens. I used an aperture of f/5.6 to emphasize the detail in the moss on the stone finial in front and ensure the finial behind appeared softer.

⊕ Anna loves to look at and study textures of natural history, like this cone of the European larch.

⊕ In Scotland, clouds are often hanging around, sometimes quite low, which can make photographs appear flat and gloomy. In the garden I am frequently either waiting for clouds to clear and show me some long awaited blue sky, or waiting for clouds to arrive to help diffuse some bright light. In this case, a delightful light haze made it easier to photograph the moss on the sides of the trees. I was able to maximize the details of the lush green while the bark of the silver birch gleamed in between. A lucky break.

↻ To simultaneously capture two textures—the sharp edges of the leaves as the main point of focus and the soft red carpet of leaves in the backdrop—I took this photograph at f/7.1. I wanted to include some detail in the foreground of the fallen leaves around the tree's base so I set my auto exposure compensation dial to + 4. This overexposed the image by four stops from the average reading it would normally expose for, fooling the camera. Although I was photographing into the rays of the sun, the branches of the maple tree provided a shield.

ANN STAFFORD

Compiling Botanical Records on Grand Cayman

→ *Striving for detail and accuracy*
→ *Showing a sense of place*

➲ I photographed Ann's botanical front garden to include as many specimens as possible. Standing tall are silver buttonwood (*Conocarpus erectus* var. *sericeus*), orange jessamine (*Murraya paniculata*), and duppy bush (*Phyllanthus angustifolius*). Below are Asian sword fern (*Nephrolepis multiflora*), blue latan palm (*Latania loddigesii*), coffee rose (*Tabernaemontana divaricata*) with bromeliads, and pygmy date palms (*Phoenix roebelenii*).

⬆ Endemic to the Cayman Islands, ironwood trees were historically used for making sturdy posts supporting many of the original houses on the island. This one grows in the middle of a wall that was built around it. I used my perspective control lens to keep the tree straight in my image, as I could not go backwards any further. Old George giant bromeliad (*Hohenbergia caymanensis*) sits in the upper branches of the ironwood.

Although Grand Cayman is just 22 miles long by 8 miles across at its widest point, this small scrap of land has held Ann Stafford's fascination for more than 40 years. Ann, a naturalist and amateur botanist, has a profound understanding of the strange geology and fragile ecosystems that give this island 250 miles south of Cuba its unique identity—an identity that is threatened from overdevelopment.

In a quiet residential suburb, Ann cultivates a private botanic garden in miniature. Although her own garden is firmly out of bounds for her tours, it is a fascinating space full of creatures great and small. Ann collects plants when it is environmentally responsible to do so and records their growth as well as the creatures they attract in the sanctuary of her own garden space. Many of the native species that grow in Ann's garden have been rescued from sites across Grand Cayman as the bulldozers have rolled in, and she grows them in order to support the indigenous wildlife that includes butterflies, day-flying moths, and small lizards.

Ann takes photographs of these garden visitors as part of her conservation work, so accuracy of scale, colour, and texture of both plants and animals are extremely important. In Ann's words: "If we don't preserve the plants, we will lose the creatures, and I am interested in what eats what." She also uses the images to promote her four-hour-long eco-tours of the natural history and cultural uses of the native plants that grow around the island, such as the endangered ironwood tree (*Chionanthus caymanensis*).

Among the 415 species and varieties native to the Cayman Islands, 21 species of higher plants are known to be endemic with a further seven species representing endemic Caymanian varieties. Perhaps the most important species are those that are endemic to a single island. Grand Cayman lays claim to the greatest number of endemic species, one of which is a shrub named after Ann herself: she came across *Casearia staffordiae* while botanizing in the Mastic Trail, and she took me to the spot where it still grows.

Grand Cayman is usually a paradise of blue skies, bright sunshine, and warm trade winds, although on rare occasions the weather turns with devastating effect, such as during Hurricane Ivan in 2004.

BEING A BOTANICAL DETECTIVE

Ann likes nothing better than to unravel a mystery about a lost species and she blogs avidly about those rediscovered in recent years such as Cayman sage (*Salvia caymanensis*) and tea banker (*Pectis caymanensis* var. *robusta*). Working with others on the island, she keeps an eye out for plants that need a helping hand but like to keep a low profile. In order to preserve plants on the island, Ann must help identify Cayman's indigenous and endemic plants extremely accurately in the first place. To record them it's important to understand where they thrive and their habit. As Ann points out, "If we don't know what's native and what's not, how will we know what to try and conserve?"

Even more than written notes, photography is a crucial aspect of keeping a scientific record, from locating specimens to showing scale.

➊ Ann took me to a cemetery to show me a specimen of tea banker sprawling weed-like across the rough ground. In the 1890s this little yellow mint was picked as a plant to drink as a refreshing and medicinal tea.

➋ Tiny blue-flowered Cayman sage is critically endangered. We located it on the side of a highway with the guidance of Ann's sketch map and by scouring the area with our eyes.

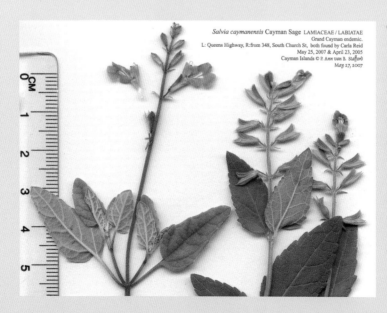

Salvia caymanensis Cayman Sage LAMIACEAE / LABIATAE
Grand Cayman endemic.
L: Queens Highway, R:from 348, South Church St, both found by Carla Reid
May 25, 2007 & April 23, 2005
Cayman Islands © P. Ann van B. *Stafford*
May 27, 2007

➌ Ann made her own botanical specimen by placing Cayman sage directly on her scanner, which can scan up to 600 percent. She made sure to turn over a few of the leaves so that the details on the underside are also recorded. Beware that lowering the scanner lid may cause the flowers to fall apart or the fruit to get squashed.

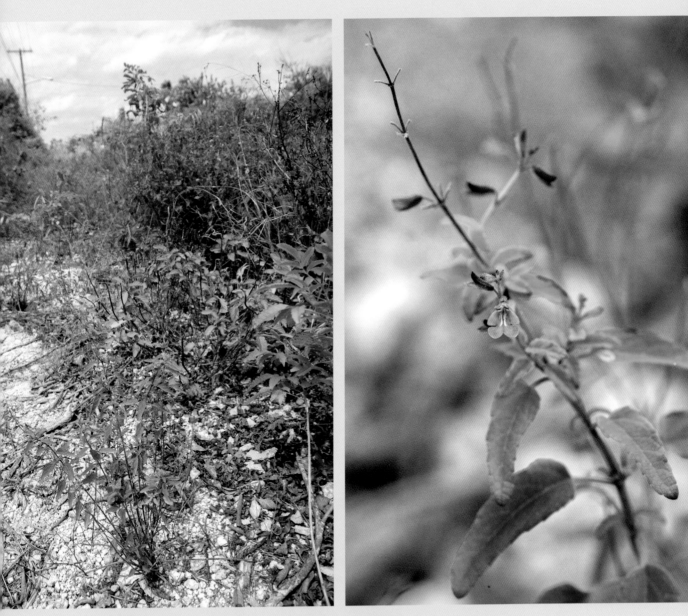

⬆ ⬈ In order to record the Cayman sage correctly I photographed the leaf as well as a close-up of the flower details.

◔ Photographing on a neutral background helped me get the colour of young bull rush (*Zamia integrifolia*) plants fairly correct, but to be more accurate including a grey card to measure by and compare later would have been better.

◕ An informal but still effective way to show scale is to use your own hand in the shot. Here I captured the approximate size of young bull rush plants.

◐ The flower of this shaving brush tree (*Pseudobombax ellipticum*) is about the same size as Ann's hand. Simply holding it is a quick and easy way to show size.

LOCATING YOUR SPECIMEN Locating rare plants is rarely easy, especially without a map or professional guide. Many mobile phones and some cameras today come with an integral GPS feature. This records your location as you capture your image. However, if your camera or device lacks this feature, it will almost certainly record the time and date a picture was taken. Therefore if you have a separate data logger that tracks your movements and maps them, you can still work out your location at a specific time by matching up the information later.

SHOWING FLOWER AND LEAF Whether just photographing plants or collecting and then scanning them as botanical specimens, it is important to show both flower and leaf for identification purposes.

GETTING THE COLOUR CORRECT Until recently, the most accurate way to record colour was via skilled botanic artists using light-safe watercolour paints. Their trained eyes were deemed more reliable than film, which can vary in colour balance depending on the brand, age, and light conditions. But with digital imagery it should be possible to reproduce colours pretty accurately. The most accurate and simple way to measure colour is to include a grey card in your image as a constant to measure against later. If you are out and about without a grey card, find a neutral background to place your specimens on. It will be possible later in your post-camera processing application to use the white balance eyedropper to get a fairly accurate colour for your specimen.

SHOWING SCALE Using a ruler in your image is a great way to accurately measure size. A more informal way to show scale is to include your own hand in the shot. An even better idea is to use a coin, as it is a standard size that the plant can accurately be measured against later.

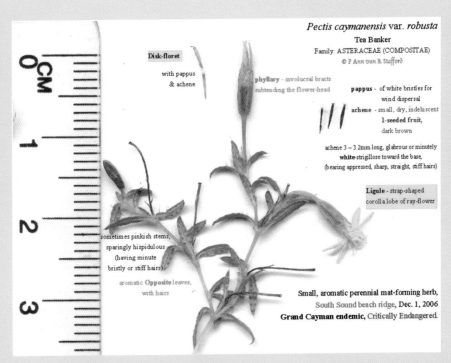

Pectis caymanensis var. *robusta*
Tea Banker
Family: ASTERACEAE (COMPOSITAE)
© P Ann van B. Stafford

Disk-floret
with pappus
& achene

phyllary - involucral bracts
subtending the flower-head

pappus - of white bristles for
wind dispersal
achene - small, dry, indehiscent
1-seeded fruit,
dark brown

achene 3 – 3.2mm long, glabrous or minutely
white-strigillose toward the base,
(bearing appressed, sharp, straight, stiff hairs)

Ligule - strap-shaped
corolla lobe of ray-flower

sometimes pinkish stems,
sparingly hispidulous
(having minute
bristly or stiff hairs)

aromatic Opposite leaves,
with hairs

Small, aromatic perennial mat-forming herb,
South Sound beach ridge, Dec. 1, 2006
Grand Cayman endemic, Critically Endangered.

↪ Here, as in all her scanned studies, Ann used a ruler to give a sense of scale. I suggested also using a grey card so the colour could be verified.

➊ For this image of a blue-throated anole (*Anolis conspersus conspersus*) and a ghost orchid (*Dendrophylax fawcetti*) I overexposed by just a third of a stop: f/7.1 at ½₅ of a second + 0.33.

➋ For this Little Cayman green anole (*Anolis maynardi* Garman) I set my auto exposure compensation dial to + 0.7 and took this photograph at ¹⁄₁₆₀ of a second at f/8 to ensure the details were as sharp as possible.

PHOTOGRAPHING CREATURES

Often when I am photographing wildlife, and especially when I am looking towards the sun at a creature that may move quickly, I set my camera dial to overexpose my image automatically in order to avoid any risk of silhouetting.

HOW PHOTOGRAPHING IN MACRO AFFECTS DEPTH OF FIELD

Depth of field normally depends upon focal length, distance to the subject, and aperture. When the first two variables are fixed, setting a higher f-stop number (a smaller aperture opening) will result in a larger depth of field. Using a much longer focal length lens or photographing closer to your subject will each result in a significantly smaller or shallower depth of field. This is because in macro photography, depth of field is primarily dependent on just aperture and magnification. Therefore at any aperture, the higher the magnification ratio, the smaller the depth of field. This explains why depth of field is so shallow in macro: the magnifications are simply much larger than in any other type of photography.

To lessen the magnification you could step back from the subject, making it take up less space in the frame. This would certainly increase the depth of field, yet if the subject fills a smaller part of the frame than intended you will be forced to crop the image in post-camera processing. While a large crop may make the subject appear as if you shot it at closer range, you will end up with less detail. Personally I would avoid this unless you simply have no other choice. Cropping may give reasonable results if you are using a camera with a capacious sensor, but it cannot help reducing the file size and therefore affects image quality, which will be especially noticeable if you want to print the picture later.

⊙ For this close-up of the leaves and fruit of the ironwood tree, I used a large aperture of f/5 to give a shallow depth of field.

⊕ Despite my using an aperture of f/10, generally considered to be a narrow aperture and offering a greater depth of field, this Mexican fritillary caterpillar on corky barked passion flower (*Passiflora suberosa*) still appears out of focus in places and the depth of field appears shallow. If you follow the rules we've talked about elsewhere in the book, this appears to make no sense. However, using a macro lens to photograph a tiny plant or creature changes depth of field because of the magnification involved. I wanted it to fill a large portion of the frame, so I had to use a high magnification ratio—meaning that the caterpillar's projection on the sensor was bigger than its actual size.

⊕ This bella moth caterpillar feeding on blue sweet peas (*Crotalaria verrucosa*) was shot using both a wider aperture of f/8 (shutter speed of ⅟₁₆₀) and a higher magnification ratio than the previous caterpillar. This means that depth of field is smaller, yet in this image the caterpillar is almost completely in focus because I adjusted the camera lens to be parallel with the caterpillar's body, allowing sharp focus on the whole creature.

↻ Butterflies have very flat bodies and wings when folded. To help maintain sharp focus throughout I took the photograph from an almost parallel position.

A better solution is to carefully position the camera so that all parts of the creature that you are photographing fall along a plane that is parallel to the lens. The focus will remain extremely shallow but as long as the details of the creature remain on the same plane, they will all remain in focus. This solution might seem basic, but just remembering to be parallel to the subject's body may be the easiest and most common solution to the depth of field problem in macro, and it works with any type of camera that can magnify your subject. Many insects have at least one flat side and many flowers have flat faces too, so this method is effective with a range of subjects.

ANN STAFFORD

⬆ This image shows the fierce Ironshore Formation limestone at Smith Barcadere (also known as Smith's Cove), one of Ann's favourite places to enjoy a swim—but not somewhere to go barefoot. Smith Barcadere is also culturally significant: the Cayman Islands have no rivers so people would come here by boat to get fresh water from wells and to harvest silver thatch tops for making into rope, baskets, hats, fans, and more. I wanted to capture the details in the texture of the Ironshore Formation limestone so I crouched low and used the contrasty shadow to illustrate all the crevices.

SHOWING A SENSE OF PLACE

When making botanical studies, it's important to include information and photographs of the area's geology. Likewise, when you are photographing your own garden you'll be aware of, for example, how some areas of ground are soft and boggy, encouraging different plant growth from fast-draining rocky areas with minimal soil. This might change from year to year depending on the weather and it might be interesting to record and then look back on over the years.

Another key to showing a sense of place is by capturing local weather. The essence of the Cayman Islands is pure bliss, calm seas, and sunshine. A lesson I have learned over the years is never to put my camera away until the last rays have well and truly gone. Many a time I have rushed back to my car to grab a camera when the light re-emerged spectacularly at the last moment.

The weather here isn't always so blissful. The rain can be dramatic and tempting to photograph, but take precautions when photographing in the rain so as not to damage your camera. It's possible to buy a rain hood for most DSLRs, and if you are really intending some intensive wet-weather photography, it may be worth investing in an underwater housing.

⬆ Ann took this beautiful picture of the endangered red mangrove not far from where she lives on the island. Photographing at the end of the day gives that warm red glow.

⬅ I took a photograph of the same red mangrove looking very much at home with the water lapping up against it. I wanted to show the roots in context and the watery environment it thrives in. I set the tripod up in the water and took several exposures, each slower than $\frac{1}{30}$ of a second to show the blur of movement, until I got the pattern in the water that I liked. I made a note to delete the many versions I was not going to use so as not to waste hard drive storage space. The resulting image was photographed at $\frac{1}{13}$ of a second at f/7.

↻ I photographed this sunset over the Caribbean Sea at Seven Mile Beach from my hotel balcony using a tripod. I didn't use the widest angle of my zoom lens but used a focal length of 70mm so as to keep the horizon nice and straight and focus the attention on the span of the sun's rays hitting the water. It's a simple symmetrical image, but it is made all the more powerful by the last ebbing rays of golden light shining through.

⬆ Torrential tropical rain bounces off the pathway from the front door to the street. Plants include (from right) myrsine (*Myrsine acrantha*), Manila palm (*Veitchia merrillii*), Christmas palm (*Adonida merrillii*), pygmy date palms (*Phoenix roebelenii*), and duppy bush (*Phyllanthus angustifolius*).

COYOTE HOUSE

Professionally Promoting Sustainability in California, USA

→ *Mixing natural and artificial light*
→ *Documenting design: before and after*

⬩ Coyote House sparkling after the rain. I was commissioned to photograph this eco-friendly house for a glossy British magazine. The property includes a green roof, solar panels, and rainwater harvesting systems, all of which I needed to show. I couldn't have timed it better. Rain is quite a rarity in this part of California but I was lucky enough to get both the rain and a rainbow directly overhead for my photo shoot. Photographed using my camera on a tripod and keeping an eye on my spirit level at 1/50 of a second at f/9.

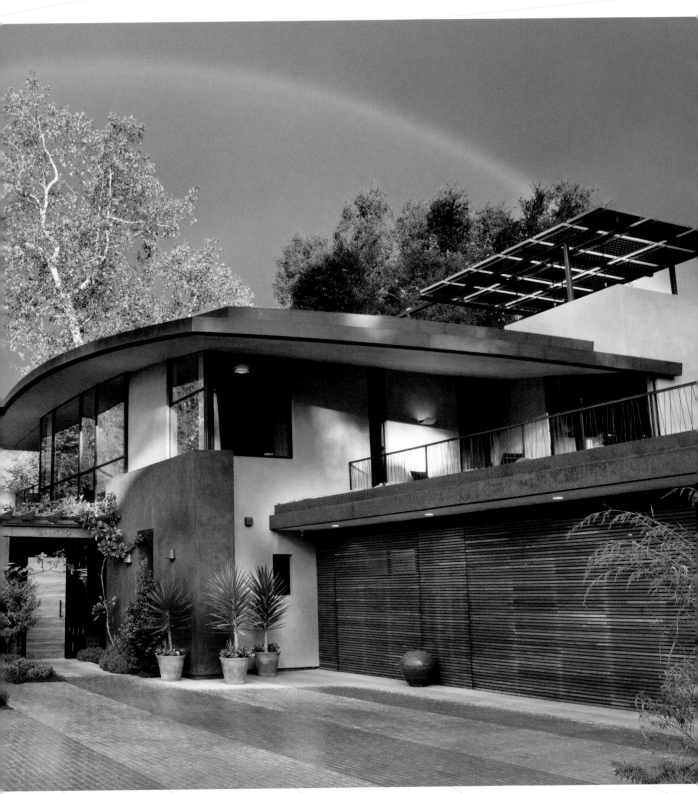

On a hillside above Montecito is a garden that flourishes while others are withering. California is in the grip of a devastating drought and water restrictions have been put in place to conserve supplies. So it was all the more spectacular that a downpour occurred shortly after I arrived for my assignment and a huge rainbow appeared in the sky above Coyote House. It seemed like a symbol of what is possible when nature is embraced in a sensitive and intelligent manner.

Coyote House is the home of architect Ken Radtkey and landscape architect Susan Van Atta, and together they have created a model for stylish and sustainable living. While keeping aesthetics to the paramount, they have considered every conceivable idea that would make their home as eco-friendly as possible. This is a property that sits lightly in the landscape, using a raft of ingenious techniques to keep the house cool and the garden blooming and productive. Floodwater is channeled into underground chambers for irrigation of the orchard and lawn of native grasses. The building is sunk into the hillside in order to maintain a stable temperature, while green roofs further cool the interior.

⬆ I love to look for patterns in nature and this detail of the green roof made an interesting repetitive design using 'Dragon's Blood' sedum (*Sedum spurium* 'Dragon's Blood') and bluff lettuce (*Dudleya farinosa*). I used an aperture of f/8 because I wanted details in a good range of the image to be sharp.

Not simply a delightful and welcoming home, Coyote House also serves as an important showcase for Ken and Susan's enlightened approach to sustainability in both of their professional fields. I was delighted to learn that they respected the work of professional photographers, commissioning the right person for the job whenever they had the need, such as on their websites, to illustrate academic and professional lectures, and in their portfolios. Yet over the years the couple (especially Ken) have also taken plenty of photos of the garden and house for their own pleasure or when a professional was not at hand. Susan explained, "Sometimes we are capturing events, such as rainstorms, that tell part of the story of our house. Seeing people, pets, and wildlife in a photo adds a lot too, and I take photos to be sure this kind of life is illustrated for our house."

MIXING NATURAL AND ARTIFICIAL LIGHT

Ken and Susan's enviably stylish home and garden provided plenty of interesting lighting situations. Strong Californian sunlight mixed with artificial light inside and outside, day and night, gave me plenty of challenges to overcome.

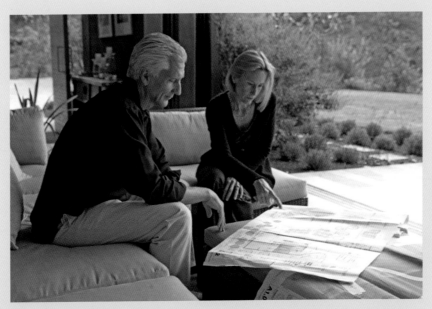

⬆ In this portrait of Ken and Susan discussing the plans for the new pool, they sit in an area with a mix of warm artificial light and natural California daylight. I colour-balanced the image in post-camera processing aiming for a natural look.

⬆ I love the inside-outside design of Coyote House, but Ken's photograph of the entrance to their living space illustrates how a combination of bright daylight mixed with dark interiors can be tricky to handle. Without using either a tripod or a camera that shoots in RAW, you would have difficulty adjusting your exposure to reveal any information in both highlights and shadows.

⬅ This view from the top of the stairs was a challenge for me to capture using a mixture of artificial light and natural daylight streaming in from the window. I wanted to show how the garden continues in a stylish way throughout their house. The air plants placed on the wall as decoration live there permanently and require little attention. My goal for the composition was to complement the geometric shapes in the overall image with the linear shafts of light.

⬆ Photographing the building at night was a joy. The couple had thought out the outside lighting well so that when I viewed the space from the outside, most of the scene was balanced by the exterior lighting. I set up my tripod, and with my Nikon camera I set my ISO to 1600—the best I knew it could handle without giving me too much graininess. I needed to take two exposures, one for the shadows and one for the highlights, but I altered the shutter speed, not the aperture, which I set to f/8. I merged the two images later in Adobe Photoshop to pull out some details in the young lavender plants.

PHOTOGRAPHING THE NIGHT VIEW

When photographing at night, be sure to allow plenty of time to set up before the perfect moment. I always prepare by working out my shot in advance, sometimes even making sketches if I have several shots to work through quickly. Set up your tripod and move any props around while you still have plenty of light to see what you are doing. Depending where in the world you are photographing, the moment between dusk and darkness can be short lived. Being set up in advance will allow you to take full advantage of this short window of time.

Using a tripod is also essential in this scenario as it's not really possible to hand-hold a camera absolutely steadily without risking any slight movement; just the involuntary movements of your muscles alone will make a difference. How much it moves depends on a lot of things—the weight of the camera and lens, and whether you are standing, kneeling, or resting against something solid, like a doorway—but to be safe, I always use a tripod when taking photographs at night.

↥ Photographing in the dark is, surprisingly, not best done at night. You can achieve much better results at dusk when ambient light is still around. If you wait until it's too dark then the camera will find it hard to record any tones between the extremes of dark and light. Aim for twilight when you can achieve the best of both worlds.

⊕ Susan and Ken may never need to have the strawberry photograms printed on cloth. "The paper functions well," they explained, "and is less expensive to replace as our ideas for the screens evolve over time."

MAKING A PAPER SCREEN

When I was photographing Coyote House, I noticed the stylish screen that Susan and Ken created to hide a storage space under the stairs where their television lives when it's not in use. The screen is botanically themed, a decision the couple made "to reinforce the overall blurring of inside to outside that characterizes our home."

The screen features the foliage, flowers, and fruits of woodland strawberries (*Fragaria vesca*), a California native that Susan had planted in the shady areas of the garden. Not only were the strawberries naturally beautiful and accessibly growing all around their home, but the form of the plant and its growth habit of spreading by runners—"often in a linear fashion, one shoot extending after another"—lent itself to display on a long vertical banner.

Ken placed the plant material on a light table in order to capture more detail in the leaves and then took photographs with a pocket-sized camera. They downloaded the images onto the computer so that they could then manipulate and arrange them and change their scale. Ken and Susan's original plan was to print heavy paper banners as mock-ups before printing them on cloth. However, they have found that the paper functions well and they can simply reprint the screens when they inevitably become faded and discoloured from the sun. Paper screens are also less expensive to replace than cloth, offering the opportunity to make new screens as new ideas arise.

⬆ Ken put these strawberry leaves on a daylight-balanced light table and photographed them from above to produce a modern equivalent of a photogram. Photograms are a way of making pictures of objects without a camera, one of the first things I was taught to do in a darkroom. You would lay out a sheet of photographic paper (bromide in those days) and lay some objects on top to form a pattern. You briefly expose the paper to light, and then develop and fix as usual. The paper would be black with white shapes left where the objects had blocked the light.

⬆ To capture an area of mixed planting in the garden, I waited for some cloud cover and used the soft light that the clouds brought to achieve this gentle effect. I love the way the soft planting complements the couple's strong but serene home.

NATIVE FLOWER GARDENS

Long before sustainability became a focus in the landscape architectural profession, Susan Van Atta's work reflected a commitment to environmentally appropriate landscape design, habitat restoration, and the use of native plants. Susan has a great knowledge of California native flora gained from years of experience working within planning—she is also the author of *The Southern California Native Flower Garden*—so the garden abounds with native species. Invasive trees, such as the highly combustible Australian eucalypts, were removed during construction and have been utilized in the fabric and furniture of the house. Plants native to this region are uniquely beautiful and can thrive on their own with minimal water, pruning, fertilizers, or soil additives. Perfect for the land around Coyote House.

I used the aperture priority mode on my camera to shoot the plant images in the garden. This means that I manually set the aperture and then the camera automatically sets the appropriate shutter speed to give the correct exposure. I tend to use this setting more than any other for gardens and plants as it's so important to me to select the amount of the image I want to appear in focus range and as, in most cases, depth of field is determined by the aperture set.

↻ For a close-up photograph of this apple tree (*Malus domestica* 'Anna'), which Susan selected for its ability to thrive in warm climates, I used a large aperture of f/5.6 to maintain the softness.

◔ Susan is closely involved with the Santa Barbara Botanic Garden and it was their horticultural team who introduced the Cedros Island verbena (*Verbena lilacina* 'De La Mina') to cultivation. Native to the Cedros Islands near Baja California and selected for its darker shade of lavender flowers, this species is highly attractive to butterflies. I photographed this image at f/5 to give the softness of shallow depth of field.

◑ I didn't want any sharpness in the background or the picture would look confusing and I'd lose the shape of this deep red pineapple sage (*Salvia elegans*), so I used a slightly larger (more open) aperture of f/4.5.

DOCUMENTING CONSTRUCTION:
BEFORE AND AFTER

From previous experience I knew that it was important to show not just the finished building or project but also some nuances of the construction process. It's hard for a photographer to take a guess at which areas have been a challenge of engineering brilliance so I find it really helpful to be given a map or plan to work with. Nuances of elevation, form, and design need to be explained—it helps to run through the problems incurred and overcome in design and construction so that the best result is enhanced. It's important to remember that the subtleties of design may be better displayed from above and/or from ground level. When a landscape architect is at work they will consider the best light for the project's function so this could be particularly important to enhance.

Although Ken and Susan are committed to hiring professional photographers to document their house and garden, situations such as documenting the construction process often call for a more casual approach. Smart phones and tablets might not always give the best results, but they are adequate for a personal record—and it's easy to have a phone always at hand.

↻ This carefully thought-out drainage area deserved documenting. A rainwater harvesting retention basin leads to a grate and then to an underground storage tank for an irrigation system. I took an angle here low to the ground so I could follow the track the water would flow through and illustrate the process, including showing the plants that would share the job of filtering the water while taking some for themselves simultaneously.

⬆ Whether you are building your own home or a garden shed, it's helpful (and sometimes entertaining) to have a before and after record. Ken took this image as the build was in progress.

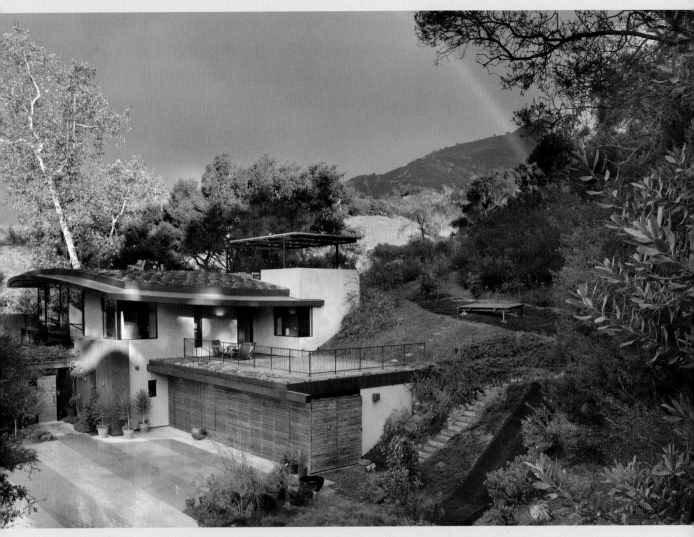

⊕ I took this matching image of Ken's earlier construction picture when the building was complete and the garden planted. I was lucky enough to get a rain shower and rainbow into the bargain. The water on the paving gave a reflective sheen, emphasizing the rich colour of the stone. Sometimes if paving is dry and dusty or concrete colourless I get out the hose pipe and drench it as evenly as possible to add richness to the tones. Take care to have your photo set up in advance though—there's nothing worse than dry patches appearing.

⊕ Ken took this image of the construction of the pool from the roof of the house using his smart phone. The pool was a later addition after the building and garden had been completed for some time.

⊖ These old bottles were found during the excavation of the pool and Susan took this image on her smart phone to document the discovery. Even if you generally photograph your garden with a compact camera or DSLR, a smart phone comes in handy when you don't have time to grab another camera but you want to capture the moment.

⬆ I was in the vicinity when the swimming pool was almost completed so I took the opportunity to photograph it. The unusual oval shape was enhanced by the reflection of the blue sky. For a landscape photograph when I want to keep as much sharply in focus as possible, I generally use an aperture of f/8 or smaller depending on what information I want to be sharp in the foreground and in the background. With my camera and perspective control lens secured on my tripod, I stood on a stepladder to keep the perspective correct. I always keep a spirit level on my camera to check I have the level straight too.

FROM GARDEN TO TABLE

Besides construction, there are other reasons why before and after shots can be useful. It's so lovely to see produce being harvested, cooked, and preserved at home—an act very much in keeping with the principles of Coyote House and a photogenic addition to the documentation. This house and garden are aesthetically pleasing and environmentally sustainable but as importantly to Ken and Susan this is also the house they live in, and the produce of the garden and the nature of the native plantings are integral to making it their family home.

❶ A round plump fig ready for chopping and preserving at its best. I photographed it using a diffuser, a reflector, and an aperture of f/5.

❷ The process of Susan making a tasty preserve from the figs she grew in her garden is another example of a construction image. In this case, Susan used her smart phone to record one of the steps she took to produce the end results.

↶ I wanted to see the detail in the seeds and the drip of the syrup from the silver spoon. So I positioned a lamp with a day-light colour-balanced bulb behind the jar but to one side, out of the shot. This gave the golden tones of the fig an amber glow. I didn't want the light to be harsh so I also put a diffuser between it and the reflective glass. Opposite the light I positioned a reflector and moved it around into position so that it would reflect the soft light's gentle highlights and make the syrup and seeds glisten.

I hope that you have enjoyed reading this book and will grasp every opportunity to get out into a garden with your camera or whatever device you choose. There is always more to learn, new techniques and products to try out, but ultimately it's about learning to use your eyes—and practise not only makes perfect but it's great fun.

RESOURCES

EQUIPMENT AND APPLICATIONS

Adobe (Photoshop, Lightroom)
adobe.com

Apple.com (iPhone, iPad)
apple.com/uk and apple.com

Nikon UK
europe-nikon.com/en_GB

Nikon USA
nikonusa.com

REFLECTORS, DIFFUSERS
lastolite.co.uk
lastolite.us

TRIPODS
manfrotto.co.uk
manfrotto.us

SPIRIT LEVELS
Various manufacturers offer double bubble spirit levels.

CAMERA BAGS
lowepro.com

LENSES FOR SMART PHONES, TABLETS
iprolens.com
mobi-lens.com
olloclip.com
photojojo.com
sonymobile.com

COLOUR CALIBRATION DEVICES FOR DISPLAYS, MONITORS, AND COMPUTER SCREENS
xrite.com

WEATHER

AccuWeather
accuweather.com

BBC Weather
bbc.com/weather

Dumfries and Galloway Dark Sky Park
scotland.forestry.gov.uk/forest-parks/
galloway-forest-park/dark-skies

Met Office Weather
metoffice.gov.uk

NASA's Visible Earth, Blue Marble collection
visibleearth.nasa.gov

Norwegian Weather Service
yr.no

FURTHER READING

Ang, Tom. *Digital Photographer's Handbook*. London: Dorling Kindersley, 2009.

Carey, David. *How It Works: The Camera*. London: Ladybird Books, 1986.

Cartier-Bresson, Henri. *The Mind's Eye: Writings on Photography and Photographers*. New York: Aperture, 2005.

Frost, Lee. *The A–Z of Creative Photography*. Newton Abbot, Devon: David & Charles, 2000.

WEBSITES

cambridgeincolour.com
If you want to get technical and learn all about sensors, colour management, and histograms, this is the place.

dpreview.com
Extensive camera and lens tests with regularly updated equipment news, forums, and challenges.

ibarionex.net/thecandidframe
The candid frame is a podcast full of inspiration interviews with photographers discussing their work and life. Not garden orientated but enlightening.

kelbytv.com
Photoshop and Lightroom tutorials from master Scott Kelby.

photojojo.com
Great blog and store for fun photography projects and accessories for your camera phone or DSLR.

rideau-info.com/photos
All About Digital Photos by Ken W. Watson is a well-informed, straightforward questions-and-answers website on many aspects of digital photography.

strobist.blogspot.co.uk
I'm not a fan of flash, especially for plant photography, but to learn about lighting and using your camera's flash, the strobist is the place to start.

ACKNOWLEDGEMENTS

Special thanks to Anna Mumford for her encouragement to embark on this project and her initial handholding through the writing process.

Also to Agnes Stevenson for her skilful interviewing of the garden owners and putting the sparkle into the scene setting of the garden portraits.

Special thanks to all the garden owners for their kindness and generosity, not only for the use of their photographs and their time being interviewed, but for their gracious hospitality when I photographed their gardens. Many put me up and fed me, and all have since become friends. To protect their privacy, some of the owners asked for me not to use their real names.

Also thanks to Jayne Littlejohn for ongoing help and agreeing to be photographed painting our wall.

And thank you to camera mentors and techie folk who have helped me with this project:

Adam Stevens

Graham Rose

Graeme Cookson

Paul Williams

Stu Culley

Robert White (an old friend who sadly passed away during the making of this book)

PHOTOGRAPHY CREDITS

Anna Maclaren, page 169 bottom; Norrie Maclaren, pages 164 top, 165. Corran, Highlands, Scotland (ardgour-selfcatering.co.uk)

Ann Stafford, pages 178 bottom, 181, 188 top. Georgetown, Grand Cayman, Cayman Islands (caymannature.ky)

Brian Wood, pages 73 top, 74, 79, 82, 84. Dublin, Ireland (murphyandwoodgardencentre.com)

Ian McKellar, pages 108, 110 top, 111, 114, 117, 118. Rosneath, Dunbartonshire, Scotland

John Makepeace OBE, pages 134, 142 top, 143 bottom. Beaminster, Dorset, England (john-makepeacefurniture.com)

Lisa Hector, pages 124, 125 right, 126, 129. Vale of Strathmore, Perthshire, Scotland (primrose-hillinteriors.co.uk)

Lynn Davis, pages 97, 101. Burien, Washington, USA

Mary Davis, pages 64 left, 67 top. Malaga, Andalucia, Spain

Nancy Goldman, pages 155, 156, 157, 159. Portland, Oregon, USA (brokenpots@yahoo.com)

Susan Van Atta and Ken Radtkey, pages 195, 198, 199, 204, 206, 208. Montecito, California, USA (va-la.com and bbird.com)

All other pictures © Andrea Jones / www.andreajones.co.uk

INDEX

ANDREA JONES specializes in photographs of landscape architecture, gardens, and plants. Her assignments have taken her all over the world and her work illustrates books, magazines, and newspapers, regularly appearing in publications such as *House & Garden*, *Country Living*, *Gardens Illustrated*, *The Daily Telegraph*, and *The Times* in the United Kingdom, and *Sunset*, *Organic Gardening*, *Fine Gardening*, and *Garden Design* in the United States. Her stock photo library is Garden Exposures.

Her photos have appeared in many books, including her *Garden Source: Inspirational Ideas for Gardens and Landscape* and *Plantw* on BBC Radio 4's *Mi* and Jackie Collins. H *Gardens of North Am The Glory of the Tree*

Andrea is a Fello exhibits her work are Photographer of the Kingdom's Garden M for both Photograph pher, and in 2014 sh and was a finalist in

LEWIS FYFE